BEWARE
OF THE
WOMAN ARTIST

FRONT COVER: Judy Chicago, *Immolation*, 1972, from *Woman and Smoke*, see p. 75
BACK COVER: Hilma af Klint, *Group IV, The Ten Largest, No. 7, Adulthood*, 1907, see p 17; Martha Rosler, *Semiotics of the Kitchen*, still, 1975, see p. 81; Barbara Hepworth, *Pierced Form (Epidauros)*, 1960, p. 34; Saloua Raouda Choucair, *Self-Portrait*, 1943, see p. 49; Marlene Dumas, *The Morning Light*, detail, 1997, see p. 87; Elizabeth Catlett, *Sharecropper*, 1952, see p. 45
FRONT ENDPAPER: Lee Krasner, *Palingenesis*, detail, 1971, see p. 37
BACK ENDPAPER: Vera Molnár, *Untitled*, detail, 1970, see p. 53

© Prestel Verlag, Munich · London · New York 2024
A member of Penguin Random House Verlagsgruppe GmbH
Neumarkter Strasse 28 · 81673 Munich

First published in French as
Les femmes artistes sont de plus en plus dangereuses
© Flammarion, Paris 2022

A CIP catalogue record for this book is available from the British Library.

Editorial Direction Flammarion: Julie Rouart
Project Management Flammarion: Delphine Montagne
Copy-Editing Flammarion: Mélanie Puchault
Proofreading Flammarion: Clémentine Bougrat
Production Management Flammarion: Chloé Brossard
Graphic Design: Marie Pellaton

Project Management Prestel: Cornelia Hübler
Translation into English: David Wharry
Copy-Editing, English Edition: José Enrique Macián
Production Management Prestel: Martina Effaga
Cover Design, English Edition: Martina Effaga
Typesetting, English Edition: Hilde Kauer, Cologne
Separations: Reproscan
Printing and Binding: Imprimerie Pollina
Typefaces: Century and Franklin Gothic
Paper: Magno Volume 150 g/m²

Printed in France

ISBN 978-3-7913-7744-5

www.prestel.com

BEWARE
OF THE
WOMAN ARTIST

Laure Adler & Camille Viéville

Prestel

Munich · London · New York

ETERNAL RENEWAL 7

WOMEN ARTISTS

Hilma af Klint **16**
Vanessa Bell **18**
Liubov Popova **20**
Charley Toorop **22**
Benedetta **24**
Kay Sage **26**
Anni Albers **28**
Louise Nevelson **30**
Germaine Richier **32**
Barbara Hepworth **34**
Lee Krasner **36**
Aurélie Nemours **38**
Gego **40**
Agnes Martin **42**
Elizabeth Catlett **44**
Carmen Herrera **46**
Saloua Raouda Choucair **48**
Elaine de Kooning **50**
Vera Molnár **52**
Irene Chou **54**
Bertina Lopes **56**
Nancy Spero **58**
Lygia Pape **60**
Helen Frankenthaler **62**
Jacqueline Fahey **64**
Faith Ringgold **66**

Marisol **68**
Nicola L. **70**
Zarina **72**
Judy Chicago **74**
VALIE EXPORT **76**
Wook-kyung Choi **78**
Martha Rosler **80**
Rebecca Horn **82**
Ana Mendieta **84**
Marlene Dumas **86**
Guerrilla Girls **88**
Katharina Grosse **90**
Tracey Emin **92**
Rachel Whiteread **94**
Françoise Pétrovitch **96**
Dominique Gonzalez-Foerster **98**
Nairy Baghramian **100**
Suzanne Husky **102**
Kapwani Kiwanga **104**
Anne Imhof **106**
Ad Minoliti **108**
Farah Atassi **110**
Claire Tabouret **112**
Njideka Akunyili Crosby **114**
Megan Rooney **116**
Kubra Khademi **118**

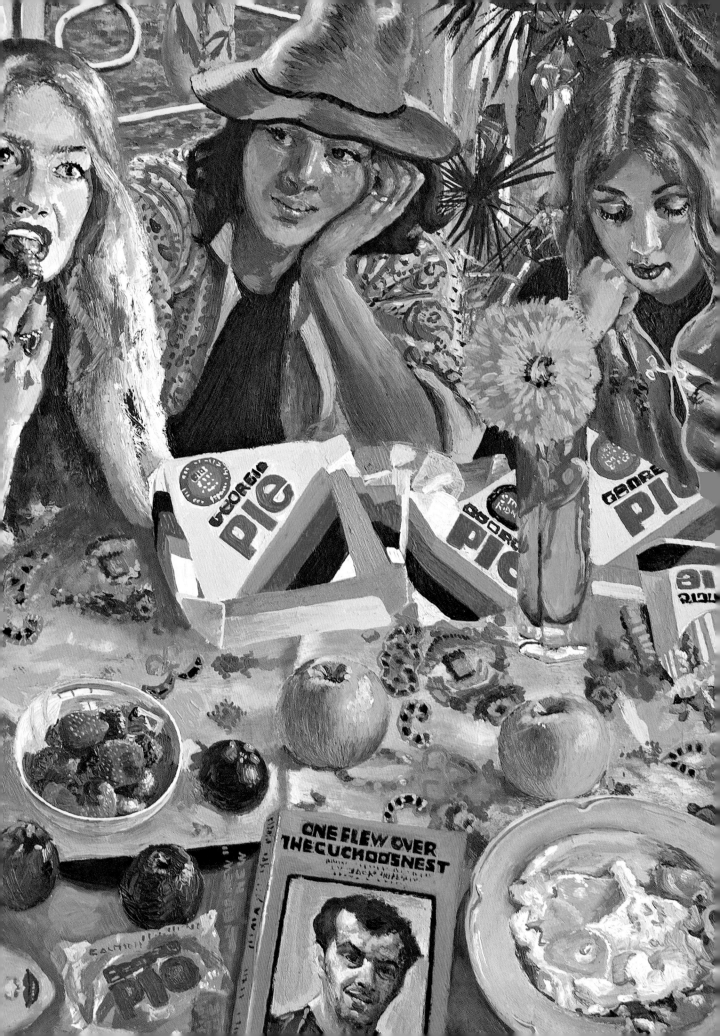

ETERNAL RENEWAL

Laure Adler

Women's lives are in eternal renewal. Every day they must prove the legitimacy of their very existence to the opposite sex. Every morning they are called upon to be at once mothers, lovers and labourers, shouldering the mental burden necessitated by this triple personality and enduring the physical and psychological strain caused by the tasks assigned to them. Every day men say to women, "Things are better than before, aren't they? So what are you complaining about?" They are, however, only partially correct. Since more than a century, although women's rights and achievements have undeniably made a tremendous leap forward in the West, and even though it is incontestable that the struggle for women's rights has gained further momentum since the Me Too movement, attracting new followers and establishing a new frame of mind in society, the struggle for female-male equality has never been a path strewn with roses along which the most fundamental rights have been won and set in stone forever, as cruelly seen in the recent ruling by the Supreme Court of the United States dealing a blow to the right to abortion. The cause of women is not a story of constant progress enabling us to believe necessarily in an easier, more joyful future. Everything may be jeopardized by questions of economics or politics. Female-male parity unfortunately remains on a sliding scale for many decision-makers when it should be considered the principal cornerstone of democracy.

This book continues the desire for recognition by women artists in the nineteenth and twentieth centuries, as well as in this twenty-first century already so promising for them. It is a desire to rehabilitate still little-known female figures but also to shine a light on young women bringing hope and promise to future generations. Today, art is no longer forbidden for those who identify as female, but this does not mean that all obstacles have been cleared. As we will see on this journey, the fruit of an active dialogue with Camille Viéville, who belongs to another generation than mine but is as committed as I am to this struggle begun a decade ago by female curators – such as Camille Morineau, cofounder of AWARE (Archives of Women Artists, Research and Exhibitions) – intent on highlighting, preserving and passing on this female artistic heritage.

As you will see, the destinies of most of these women are extraordinary, each of which would merit its own monograph. One cannot help but admire the moral and mental strength they have shown in continuing to create despite trials and tribulations and the fact that they did not use their energy in the service of making themselves famous but rather in persevering – to persevere even when their belief faltered in their own talent or when accepting a mindset whereby men have long exercised their dominance in the choice of artists and their position on the art market. Even today, a female artist is worth less than an equally famous male artist.

p. 6
JACQUELINE FAHEY
Georgie Pies for Lunch, detail, 1977, Collection of Philippa Howden-Chapman and Ralph Chapman, Wellington, see p. 65

8

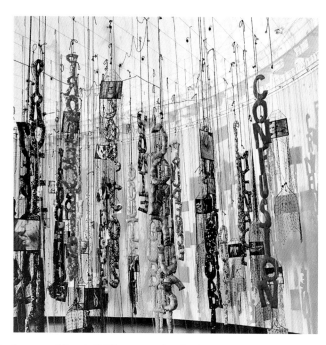

ANNETTE MESSAGER
Installation at the Hamburger Kunsthalle, Hamburg

In this respect, the place of women artists in the public sphere today, and what society permits us to understand of their vision of the world, is a question of principle, in both the real and symbolic sense because it allows us again to measure the freedoms they enjoy and the belief we have in their power to fire our imagination. Clearly, even if there have been notable steps forward – the result, as always, of protests by female artists no longer willing to tolerate their quasi-invisibility, particularly in museums – to be recognized as an artist is still an uphill battle. It is not so much that men are preventing this recognition but rather that traditions, education and societal clichés lead us, more or less consciously, to believe and think that since antiquity male artists alone have defined the rules of and criteria for beauty, and to such an extent that we often still believe that they are their perpetual heirs.

This is undoubtedly the reason why, because we were born female, we were barred from attending art schools before the 1880s, where men shared among themselves their knowledge and way of seeing the world and their *and our* gender. It was not for want of trying – women have never ceased trying and the force of this prohibition only spurred them on – but that their creations were never truly regarded as art in its own right. Take, for example, medieval illuminated manuscripts. We now know that although women were responsible for many such marvels, they were regarded merely as copyists, whereas men were championed as the creators. Consider also all the masterpieces of embroidery, lace, needlepoint, spinning, knitting and weaving, all considered "craft", mundane and manual, so-called "women's work", and therefore inferior and unworthy of being seen as works of art. I am delighted to see female artists now proudly asserting such creative output, including their forerunner, the mischievous, brilliant Annette Messager, who more than forty years ago embarked on her artistic journey alone. Annette says she is an artist who also happens to be a woman. She never tried to work like a man or as if she were not a woman, so she began work as an apprentice seamstress – a *petite main*, or "little hand", in French. She asserted what women know how to do and the singularities of these skills. She protested against certain representations relegating women to a secondary status. She did so by making fun of them with puns and devilish drawings, deconstructing female clichés with a poetic, sexual alphabet. For a long time she was called a witch as, alas, all creative women are. If they create then something must not be right, something

9

is out of the ordinary; there is some excess, even hysteria, a humoral imbalance has gone to their head. Annette Messager enjoyed being called a witch, a title bestowed for centuries on women endowed with special "gifts" or "powers" and also claimed by feminist artists, such as the American Judy Chicago and the Afghan Kubra Khademi, both present in this book, who turn this insult into a totem. Most of these women continue to break rules, even if their reputation is now established. Some have drawn strength from this and have gone even further in their search for their inner self and attempts to understand the body, such as Marlene Dumas and Rebecca Horn – to understand their body, intimacy, sex, the fire of sex. One must admire the courage and determination of Louise Bourgeois, who had to wait until very late in life to be at last recognized, and Frida Kahlo, who in her deeply moving paintings expressed her innermost sufferings and paid so dearly for it psychologically, and Niki de Saint Phalle, who was regarded for a long time as unhinged for her *Nanas*, now celebrated the world over.

Every affirmation of female power unleashes the boomerang of male domination: the struggle for the perpetuation of male hegemony. One does not give up thousand-year-old privileges in a few decades. This supremacy has given them the advantage of depicting *us* without us being able to retort. *They* possessed the codes, the keys, the characterizations and depictions of "woman" and their subjectivity against our absent us. Why did *we* refuse for such a long time the right to draw, to paint, to represent the world? Was it men's preventive caution against the dangers of the liberation of female imagination, a fear of lack of control? Were we ever so dangerous?

Art has no gender. It is not because one was born female that one has more capabilities, possibilities or chances of becoming an artist. It is not because one is a female artist that one is more gifted, creative or singular than someone of the opposite sex. Indeed, some artists dismiss their gender, affirming loud and clear that they have never even given it a thought. I am thinking of Joan Mitchell, the extent of whose work could be recently rediscovered at the Fondation Louis Vuitton, and Etel Adnan, whose fame has only increased since her death. Both were geniuses of colour and artists of light. Both never used representations of their gender in their work to express their relationship to the world, and it would be impossible to recognize them as women if their works were displayed without their signatures. Is art the putting under tension and active forgetting of all personal ties in order to project oneself into the universal? Without a doubt, it is that too, but it would mean ignoring the silence and oblivion inflicted upon creative women over the centuries to maintain that the history, the present and future of female artists do not bear the traces, echoes, demands and grievances – notably in very recent times – that can repair the gaping black hole created by their absence.

Women have taken charge of this themselves and that has changed everything. Seeing, showing oneself, being seen. Before, men often regarded women as objects, and for much of history, women have been represented by seductive charms, as the adornments of power, bodies on display, as non-subjects. This did not prevent some from considering themselves the equals of men: Élisabeth Vigée Le Brun, Adélaïde Labille-Guiard and Artemisia Gentileschi are some who come to mind. These powerful women often served as warnings because they were such exceptions. But how many know Hilma af Klint's work? Af Klint, the first to feature in this book, was so aware that she was ahead of her time that she demanded a delay of twenty years after her death before some of her paintings were to be exhibited. Fortunately, times have changed. At long last, Toyen triumphed, at the Musée d'Art moderne in Paris. Nicole Eisenman could be celebrated at the Fondation Vincent van Gogh in Arles. Women artists are now being acclaimed in galleries, certain museums and contemporary art biennials, such as in Venice. The war has not yet been won, but ground has been gained. The challenge now for female artists – happily increasing in number – is to be recognized for their creative output and to be able to exhibit. Male artists continue to dominate the art scene and have many more retrospectives. It is no longer a question of impossibility but of place, of recognition and also of education. Today – and this is a historic opportunity to be taken advantage of – museums are realizing the public enthusiasm for women artists. So let's surf on this wave of desire for beauty and egalitarian recognition. Let's make sure that this parity in visibility becomes a custom, an obvious non-question. The facts are glaring: the creations of female artists are rich, diverse, numerous, disruptive and joyous.

The aim of this book is to further retrieve little-known artists from oblivion and to highlight works by the younger generations interfering with our habits and surprising us with the power of their radicalism and commitment. Benefiting from the legitimacy acquired by their forebears, these women no longer have to engage in this exhausting

ADÉLAÏDE LABILLE-GUIARD
Self-Portrait with Two Pupils, 1785, Metropolitan Museum of Art, New York

and fruitless struggle. Affirmative action! There's no time to lose. In the 1970s, female artists collectively fought for their recognition, but today it seems that each creator has her own world to express and the necessity now is to deliver and transmit this. These young women constitute an infinitely varying cartography, both in the materials, formats and increasingly inventive means of expression they use. Today, without indulging in blind optimism, these new talents are increasingly well identified – for example, Zineb Sedira represented France at the Venice Biennale, and Kapwani Kiwanga was awarded the Marcel Duchamp Prize – but it is still difficult to break down these barriers. We call upon male curators to try even harder to exhibit female artists before they reach old age and not to "marry" them with men in exhibitions. One single woman will suffice, but a group of women, a whole host of women will continue to surprise us. Take the very recent fervour on seeing for the first time the work of Mirdidingkingathi Juwarnda Sally Gabori, a contemporary Aboriginal Australian artist unknown in France. She began painting at over eighty years of age and continued up until her death, showing us with her impressive formal freedom in an apparently abstract form the pain of exile from her native island, the quest for her people's right to be recognized and the lost paradise of her sunbathed childhood. This is only the most recent bedazzlement in a story that continues to surprise us, to move us and nothing less than to transform us.

MIRDIDINGKINGATHI
JUWARNDA SALLY GABORI
Thundi, 2010,
Private Collection, Australia

p. 15
NJIDEKA AKUNYILI CROSBY
Wedding Souvenirs, detail, 2016,
Private Collection

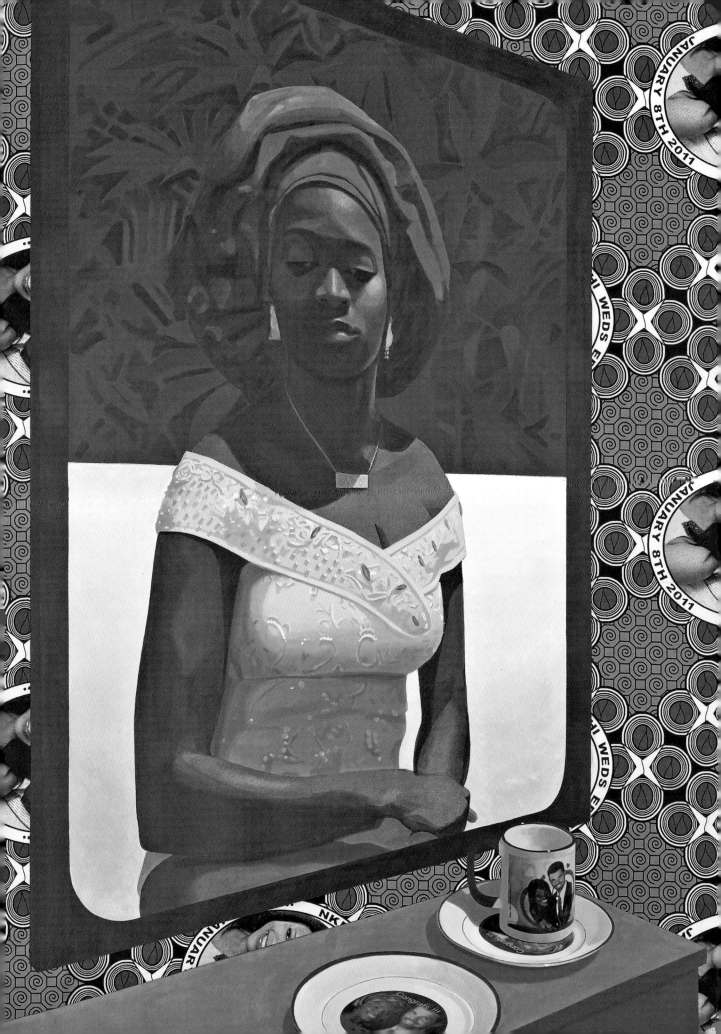

HILMA AF KLINT

(1862–1944)

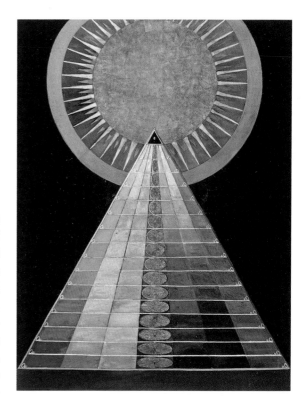

Hilma af Klint's extraordinary artistic trajectory began at the Royal Academy of Fine Arts in Stockholm, one of the first art schools to admit women, where she acquired the technical mastery she would employ to express her esoteric inspirations, first beginning in 1906. Frequenting theosophical circles, during a spiritism séance she was instructed by a spirit to create a temple and undertake its decoration. She immediately abandoned traditional landscape painting and portraiture and began a vast series of mediumistic pictures, *The Paintings for the Temple*. Painted from 1906 to 1908 and from 1912 to 1915, this series eventually comprised a breathtaking 193 works. Af Klint also began designing the sacred edifice destined to house these paintings, an almost round building on three levels linked by a spiral staircase, that was never built.

The Paintings for the Temple, characterized by their non-figurative iconography and richly coloured palette, established Hilma af Klint as one of the first artists to explore abstraction, before Wassily Kandinsky, Piet Mondrian and František Kupka, those long regarded by art historians as the forefathers of abstraction. The relationships between her geometric or organic forms and colour were guided by the key theosophical principles of harmony, the links between the visible and the invisible and the male and the female. The series is structured by sub-series, such as *The Ten Largest*. In September 1907, af Klint had a vision of ten large paintings of a "heavenly beauty" depicting the ages of life, which she then painted in forty days. These botanical and biomorphic compositions rendered in vivid colours symbolize humanity's relationship to nature.

Aware that she was ahead of her time, af Klint stipulated that *The Paintings for the Temple* should not be exhibited until twenty years after her death. They were not rediscovered until 1986 and then more widely in 2018 at the major retrospective of her work at the Solomon R. Guggenheim Museum in New York.

Group IV, The Ten Largest, No. 7, Adulthood, 1907, Hilma af Klint Foundation, Stockholm

↑ *Group X, No. 1, Altarpiece*, 1915, Hilma af Klint Foundation, Stockholm

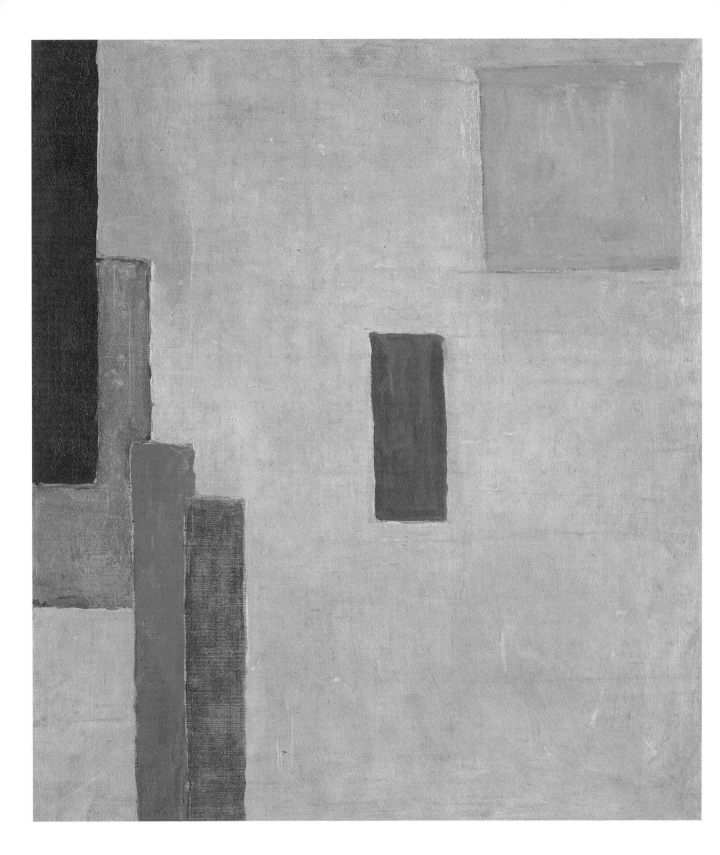

VANESSA BELL

(1879–1961)

After studying at the Royal Academy Schools in London, Vanessa Bell (née Stephen) became one of the leading lights of the famous Bloomsbury Group alongside her sister Virginia Woolf. Founded shortly before the outbreak of the First World War, this London circle of writers and painters included Clive Bell, Duncan Grant, Roger Fry and Leonard Woolf. From late nineteenth-century French impressionism and post-impressionism, Vanessa Bell borrowed her vivid, expressive palette. She was also interested in "significant form", the predominance of a picture's formal elements as theorized by her husband, Clive Bell (1881–1964), in 1913 and published in his book *Art*: "Let no one imagine that representation is bad in itself; a realistic form may be as significant, in its place as part of the design, as an abstract. But if a representative form has value, it is as form, not as representation."

Motivated by her taste for the decorative arts, in 1913 Vanessa Bell founded the Omega Workshops with Grant, now her partner, and Fry. Aided by other artists, they designed and marketed furniture, household linen, garments and ceramics, abolishing the distinctions between the "major" and "minor" arts and between painting and handicrafts. This experimentation, notably in textiles, prompted Bell to paint four abstract paintings in 1914/1915, including *Abstract Painting*. On a yellow ground, she painted rectangles and a square in blue, green, violet and reddish hues. Europe had been torn apart by war for several months and abstraction also seemed to her to be a means of symbolically opposing the conflict.

Although this radical foray into abstraction was short-lived, she continued it in several ways, using for example geometric backgrounds in her portraits (e.g., *Mrs St John Hutchinson*, 1915, Tate, London) and in her experimentation in craft. With Grant, she decorated their country house and apartments in London and worked with her sister Virginia Woolf and Virginia's husband, Leonard, for the publishing house they established together, Hogarth Press, designing the covers of several books.

Abstract Painting, c.1914,
Tate, London

↗ *The Other Room*, late 1930s,
Private Collection

19

LIUBOV POPOVA

(1889–1924)

In 1871, art schools in the Russian Empire preceded their Western counterparts by several decades by opening their doors to women. This meant that at the beginning of the twentieth century, in the context of the 1905 revolution and the struggle for social equality, many female artists, as well as gallery owners and theorists, actively participated in avant-garde movements. After training in the private school of Konstantin Yuon and Ivan Dudin, Liubov Popova travelled widely, mainly in Europe, where she enthusiastically discovered cubism and futurism, two of her major influences along with traditional Orthodox icons, Giotto and the Italian High Renaissance. She later worked in the Moscow studio of Vladimir Tatlin and provided financial support to the Supremus group founded by Kazimir Malevich. With them, she turned to abstraction and the purity of the painted surface. In 1916, she began a series of paintings called *Painterly Architectonics*. In these non-figurative works strongly rooted, as their title indicates, in the medium, she establishes dynamic relationships between geometric forms, coordinating them to create an overall system. This *Painterly Architectonic*, dated 1917, reveals her meticulous construction in which each module (quadrilateral, triangle, etc.) and each colour (white, pink, red, grey and black) interact.

In the same year, the Bolshevik revolution of 1917 encouraged Popova and her friends in their quest for an artistic language in accordance with this new world. Close to constructivism, she taught and disseminated her aesthetics in more popular forms, such as the theatre (in the production, set and costume design) and industrial textile production. In "Commentary on Drawings", published in 1921, she wrote, "the role of the 'representational arts' – painting, sculpture and even architecture [...] – has ended, as it is no longer necessary for the consciousness of our age, and everything art has to offer can simply be classified as a throwback."

Painterly Architectonic, 1917,
Museum of Modern Art, New York

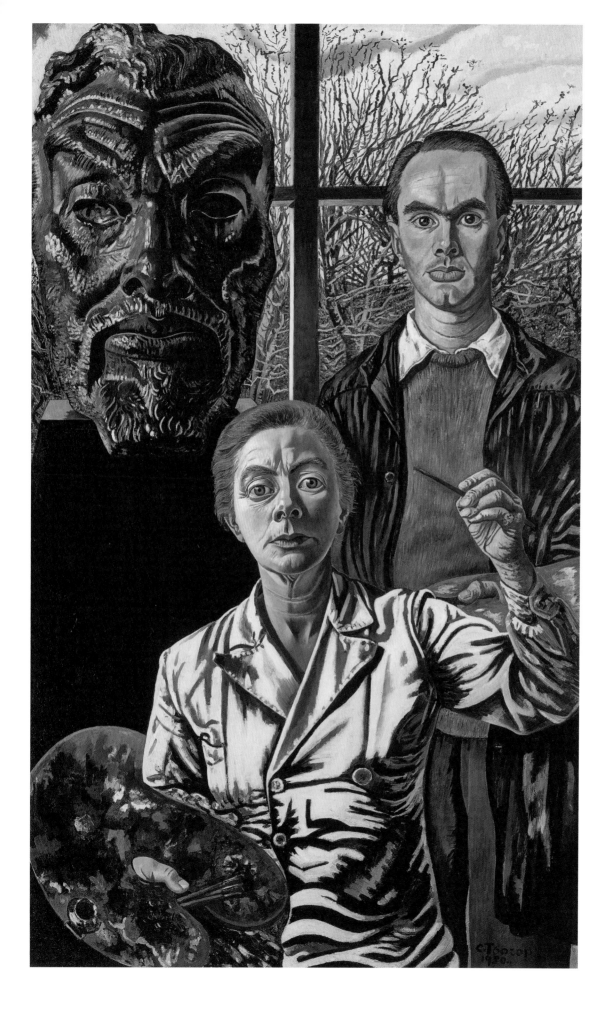

CHARLEY TOOROP

(1891–1955)

Taught by her father, the symbolist painter Jan Toorop (1858–1928), Charley Toorop produced a powerful and singular oeuvre influenced by Vincent van Gogh's Dutch period. Although an admirer of Piet Mondrian and Gerrit Rietveld, she never deviated from figuration in her still lifes or, above all, in her hieratic portraits. She was one of the artists who proposed a different path to the modernism radically defined by the abstract movements and retained her independence throughout her life.

Guided by her social sensibility, Toorop painted mundane everyday objects (e.g., *Still Life with Oil-Can and Clogs*, 1946–1949, Kröller-Müller Museum, Otterlo) with the same attentiveness that she paid to the physiognomy of her friends (e.g., *The Meal Among Friends*, 1932/1933, Museum Boijmans Van Beuningen, Rotterdam) or her children. Their meticulously, almost systematically depicted faces characteristically have very large, thoughtful eyes, a broad, flat forehead and possess a strong sense of gravity.

Three Generations, 1941–1950, Museum Boijmans Van Beuningen, Rotterdam

↗ *Self-Portrait*, 1928, Museum Boijmans Van Beuningen, Rotterdam

In *Three Generations*, Charley Toorop portrays herself in a painter's smock, palette in hand, with her brush raised, ready to paint. Behind her, we see her son, Edgar Fernhout (1912–1974), also an artist, and a monumental bronze head of her father by the sculptor John Rädecker. All three faces gaze out at us with the same intensity. Toorop enlivens the picture surface with networks of sinuous lines formed by wrinkles, hair, stubble, wool, branches and clouds, which seem to link the figures to each other and their surroundings, the artist's studio in Bergen and the immediate vicinity visible outside the window. In an 1930 interview for the magazine *De werkende vrouw* ("The working woman"), she declared, "If you really want to apply yourself as a woman and a mother – completely – it is impossible to fully carry out your work as an artist. Of course, this is a struggle. To be a mother is also to create daily, even when your children are grown up, and I have always linked them and my work; I have involved my children in it."

BENEDETTA

(1897–1977)

The work of Benedetta – born Benedetta Cappa, but who signed her works with only her given name to protest patriarchal tradition – has now been all but forgotten. The main reason for this disregard is the proximity of the second generation of futurism (after the First World War), of which she was a member, to the regime of Benito Mussolini. In Milan, she studied in the studio of Giacomo Balla, who introduced her to the futurist group's theorist, F. T. Marinetti, whom she married in 1923. Benedetta's pictures illustrate the principles developed by the movement in the 1910s, those of an artform grappling with the modern world and its technological dehumanization in which movement and energy play a crucial role.

In the early 1930s, Benedetta was commissioned by the fascist state architect and engineer Angiolo Mazzoni to paint a series of large murals for the new central post office in Palermo, the Palazzo delle Poste. The aim of Mussolini's regime was to glorify Italian infrastructure, its efficiency and power, while evoking the grandeur of ancient Rome and its art. For the walls of the conference room, Benedetta imagined a large detachable fresco in the traditional media of tempera and encaustic depicting natural and industrial landscapes as seen from the cockpit of a plane. She played on tensions between the earthly and the heavenly, reality and fantasy, frontiers and the infinite, near and far, past and future. In 1929, Benedetta enthusiastically signed the "Manifesto of Futurist Aeropainting", a new, synthetic and dynamic vision of the world enabled by the power of machines. The modification of perception by technical progress was not a futurist monopoly and many artists were fascinated by it from the 1930s onwards. But within the context of Italian fascism, futurist imagery conveniently suited Mussolini's propaganda and, following the example of F. T. Marinetti, the futurists saw this favourably.

Synthesis of Communications, 1933/1934, Palazzo delle Poste, Palermo

KAY SAGE

(1898–1963)

Born into a wealthy family, Kay Sage grew up between the United States and Europe, during long stays with her mother. Receiving her first artistic training at the Corcoran School of the Arts and Design in Washington, DC, in 1919/1920, she then studied in Rome, where she lived for almost twenty years and was influenced by Giorgio de Chirico, whose work she first saw at the Venice Biennale of 1932. In 1937, she moved to Paris, met the surrealists and forsook abstraction for dreamlike and often uncanny figurative imagery. She was one of the first American artists to adopt some of the principles of surrealism in her own visionary style. However, she was never accepted by André Breton and the surrealist group because they considered her too bourgeois, independent and wayward to fulfil the role of muse they normally assigned to women in their entourage.

When she returned to the United States in 1939, she helped her friends flee France and the war, settled at Woodbury, Connecticut, with her husband Yves Tanguy and exhibited in the New York galleries of Pierre Matisse, Catherine Viviano and Julien Levy and at the San Francisco Museum of Modern Art. In contrasting, earthy hues and with glacial precision she depicted draped figures and massive architectural forms in empty, desolate landscapes (e.g., *The Wind in a Corner*, 1949, Norton Museum of Art, West Palm Beach). She also produced works on paper with more organic forms (e.g., *Constant Variation*, 1958, Whitney Museum of American Art, New York). When Tanguy died in 1955, she dedicated herself principally to promoting her late husband's work and compiling the catalogue raisonné of his oeuvre before committing suicide by shooting herself in the heart.

I Saw Three Cities illustrates the principal characteristics of Sage's work: her figurative yet enigmatic iconography set amidst monumental forms within sterile settings executed with clinical precision in subdued colours. The draped figure, inspired by the famous *Winged Victory of Samothrace* (c.200–185 BC, Musée du Louvre, Paris) and seen in profile, imbues the entire composition with an air of disturbing strangeness.

I Saw Three Cities, 1944,
Princeton University Art Museum,
Princeton

ANNI ALBERS

(1899–1994)

In 1922, Anni Albers (née Fleischmann) enrolled at the Bauhaus, the famed avant-garde art school then based in Weimar. After a year of the preliminary course followed by all students, she was obliged to join the weaving workshop, then compulsory for women at the school. However, taking advantage of this constraint, she rapidly found textile design to be a radically experimental medium and a means of abolishing the distinctions between high and low art, between painting and crafts. Her earliest large-scale woven works already revealed her sense of rhythm, materials and colour (e.g., *Black-White-Red*, 1926/1964, Bauhaus-Archiv / Museum für Gestaltung, Berlin). When the Bauhaus moved to Dessau, into a building designed by Walter Gropius, this inspired Albers to reflect on horizontal and vertical lines, pared-down forms and light. In the late 1920s and early 1930s, she executed commissions, published theoretical texts and showed in several exhibitions. Shortly before the Bauhaus was forced to close under pressure from the Nazi regime in 1933, Philip Johnson, then a curator at the Museum of Modern Art in New York, discovered one of her tapestries and enabled Anni Albers and her husband, Josef, to take up teaching positions at Black Mountain College, a progressive liberal arts college recently opened at Asheville, North Carolina. Nurtured by the communal life in a rural, liberal environment, the couple developed the passion for pre-Columbian art that would become a major inspiration for Anni (e.g., *Red Meander*, 1954, Private Collection). In the 1950s and 1960s, she received major commissions (e.g., Jewish Museum, New York) before abandoning weaving to devote her late years to printmaking.

Pasture shows how Anni Albers's abstraction was often rooted in reality. In this "meadow" of tightly woven green threads, touches of vivid red and creamy white bloom like wildflowers in spring. The overall harmony, subtle colours and inventiveness she deploys within the strict constraints of the warp and weft are recurrent characteristics of her work.

Pasture, 1958, Metropolitan Museum of Art, New York

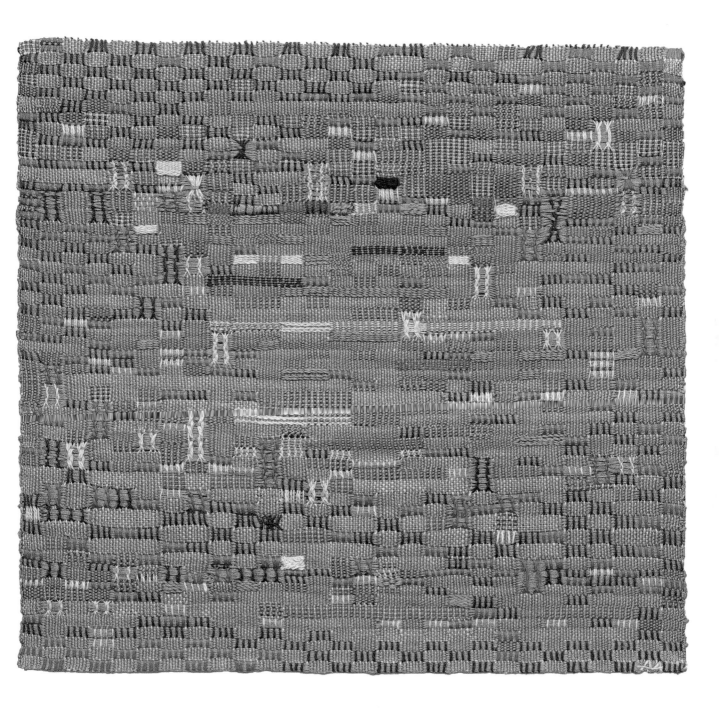

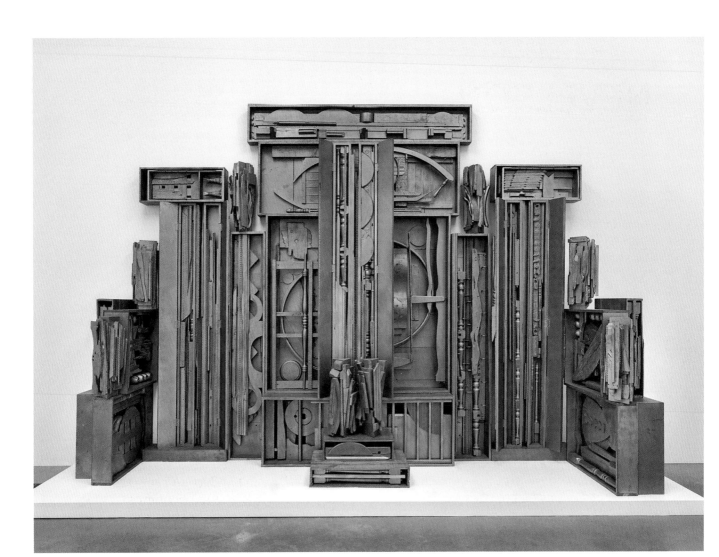

LOUISE NEVELSON

(1899–1988)

Born near Kyiv, then raised in the United States, Louise Nevelson (née Leah Berliawsky) went on an edifying tour of Europe in the 1930s before returning to enrol at the Art Students League of New York. Greatly influenced by cubism, traditional African art and pre-Columbian art, she gradually forsook traditional sculpture, and in the 1950s began creating sometimes monumentally ambitious mural constructions made from wood salvaged on the streets of New York. In compartments formed by boxes and crates, she affixed chair legs, slats, dowels and other elements in turned wood. At a later stage, she arranged combinations of these units, creating rhythms of void and matter, light and shade, surface and depth, which the monochrome black, white, gold or silver paint harmonizes by effacing these objects' original functions. The idea of movement prevailed for an artist fascinated by dance, and it was not uncommon for her to modify a work regarded as finished by removing cells. In such pieces, she engaged in a reflection on linearity, flatness and surface contemporary to that pursued by Barnett Newman, Mark Rothko and Clyfford Still in painting.

An American Tribute to the British People is composed of thirty-five compartments assembled over a four-year period, then coated with gold paint which the artist described as something alchemical. The particularity of this work is that its lateral units jut out to delimit a space. Shortly after Nevelson donated it to the Tate Gallery in 1965, her art dealer, Arnold B. Glimcher, wrote to the institution's curators, "Mrs Nevelson does, in fact, feel that this particular work is especially appropriate for your monarchial country. Its cathedral-like aspect, which seems to present the viewer with an altar at which to kneel, perhaps to receive some royal blessing, and its gilded splendour [...] were considered peculiarly appropriate."

An American Tribute to the British People, 1960–1964, Tate, London

↗ *Portrait of Louise Nevelson* by Hans Namuth, 1977, Smithsonian Institution, National Portrait Gallery, Washington, DC

GERMAINE RICHIER

(1902–1959)

Germaine Richier was taught sculpture from 1920 to 1926 by Louis-Jacques Guigues, a former collaborator of Auguste Rodin, then worked in the studio of Antoine Bourdelle until 1929 before becoming a teacher herself. Throughout her life, she pursued her interest in the figure and its relationship to the base, which she integrated into each piece. Although sympathetic to surrealism, she forged her own independent path, which partly explains why, despite her success during her lifetime, she has remained a marginal figure in the history of modern art. Her main subject is the representation of the human being, accompanied by the search for the right form, but also the expression of humanity's excesses, sufferings and tragedies. Seeing the bodies at Pompeii transfixed in volcanic ash in 1935 left a lasting impression and inspired her organic, expressive approach to the medium. During the 1940s, she created her first chimeric figures, half-man half-beast (grasshopper, ant, spider, etc.), reflecting her attachment to nature, including its most disturbing and repellent aspects. Similarly, she created hybridizations of wood, metal and stone, which further nourished her thoughts on structure. The *Christ* she created in 1950 for the church at the Plateau d'Assy in Haute-Savoie caused scandal among Catholics: not only was it the work of a woman, but it also melded the crucified, emaciated and elongated body of Christ with the Cross on the same formal plane. The sculpture was not installed until 1971 above the church's altar for which it was conceived.

In 1947/1948, Richier created *Storm Man*, a nude, faceless male figure with a massive, coarsely textured form like a tree trunk or rock. "I would say, he is formidable, this man", wrote the poet Francis Ponge, "that he had never been wilder, more thunderstruck, more woken by his own storm". This sculpture then engendered the figure's female counterpart, *Hurricane Woman*, just as brutal and formless and inspired by the uncontrollable violence of nature.

Hurricane Woman, 1948/1949,
Musée national d'Art moderne,
Centre Pompidou, Paris

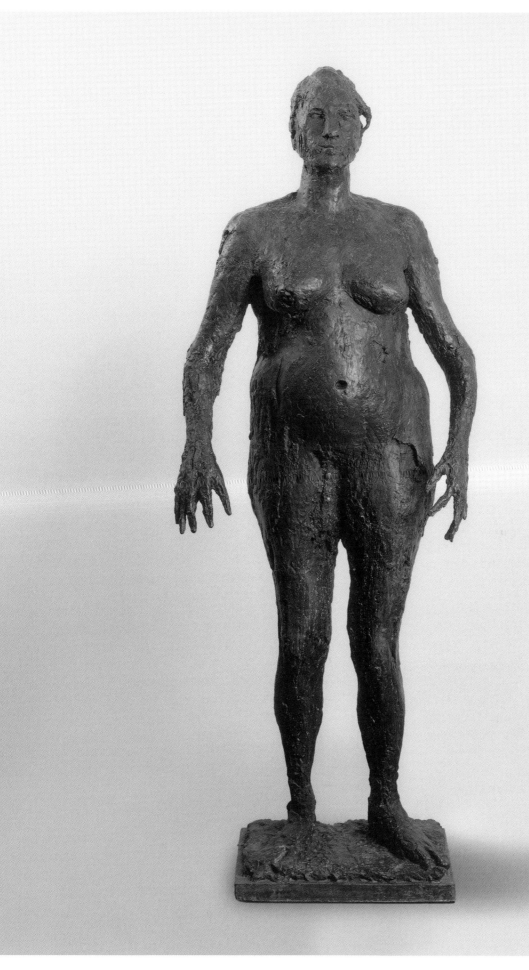

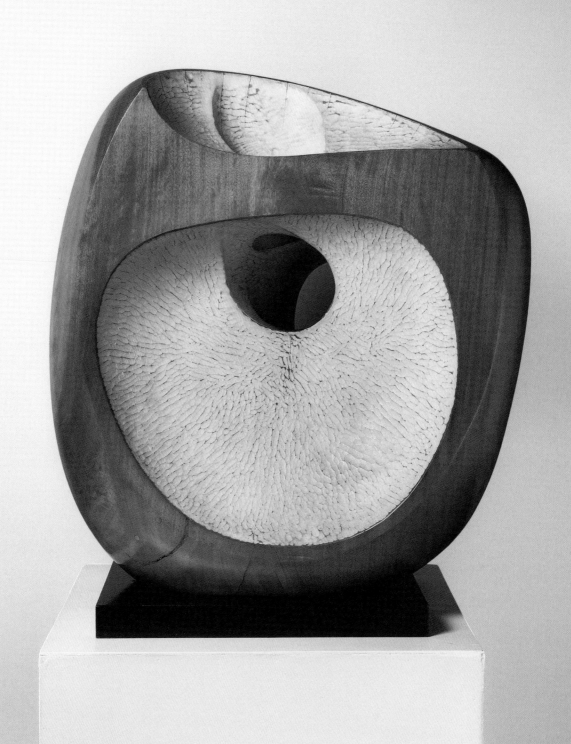

BARBARA HEPWORTH

(1903–1975)

Barbara Hepworth is one of the great modern British sculptors. Very early on, she freed herself from the academic training she received at the Leeds School of Art and the Royal College of Art, London, with her powerful simplification of form. Her initiation to stone carving during a stay in Italy stimulated her attachment to the sculptor's direct struggle with the medium. Her early sculptures of animals and human beings soon gave way to non-figurative geometric and biomorphic forms. In 1931, in the first of her long series of *Pierced Forms*, the gaping hole in the pink alabaster creates an interplay between the solid and the void, exterior and interior, light and shade. She augmented these pierced forms in the 1940s with tightly laced string and vivid colours. Her move to St Ives on the Cornish coast during the Second World War inspired sculptures resembling abstract landscapes. Institutional and commercial success came in the 1950s with prestigious exhibitions, notably at the Venice Biennale. She died in 1975 in a fire that engulfed her studio, which was inaugurated the following year as the Barbara Hepworth Museum.

At the beginning of the 1960s, Hepworth produced new *Pierced Forms* prompted by her desire to return to carving and a more direct relationship with the materiality of her medium – a victim of her success, during the previous decade she had mainly produced bronzes and casts to cater to the demand from collectors. In *Pierced Form (Epidauros)*, an evocation of her visit to the remarkably well-preserved ancient theatre at Epidaurus during a Greek cruise in 1954, the contrasting relationship between the polished guarea wood on the outside and the white, chiselled interior give the sculpture its strikingly organic presence.

Pierced Form (Epidauros), 1960,
Tate, London

LEE KRASNER

(1908–1984)

With her husband, Jackson Pollock, whom she met in conjunction with the *French and American Painting* group exhibition at New York's McMillen Gallery in 1942, Lee Krasner belonged to the first generation of abstract expressionists (she was the only woman) championed by the critic Clement Greenberg. She studied at several New York art schools, then in Hans Hofmann's studio, and in the 1930s took part in the Works Progress Administration (WPA) programme established by President Franklin D. Roosevelt to aid artists during the Great Depression. In the mid-1940s, at the same time as Pollock, Krasner experimented with "all-over" painting in her *Little Images* series, covering the entire picture surface with painted forms to accentuate its two-dimensionality. It was also during this period that she began to exhibit regularly.

In the late 1940s, Krasner painted pictures composed of dense webs of paint drippings and colour splotches (e.g., *Untitled*, 1949, Museum of Modern Art, New York). She eventually began nesting forms – squares, symbols – in one another to enhance the compositional structure. She then introduced more curves and diagonals in larger formats painted in Pollock's studio after his death in 1956. Following her mother's death in 1959, she abandoned colour in a series of pictures painted at night in artificial light (e.g., *Night Watch*, 1960, Seattle Art Museum). In 1965, at the Whitechapel Gallery in London, she had the first of a long line of retrospectives. Eight years later, the prestigious Whitney Museum of American Art in New York showed recent large-format works such as *Palingenesis* (1971), an articulation of her favourite green and pink forms on the theme of rebirth. As feminist art was emerging, Lee Krasner admitted to the art critic Cindy Nemser, "It's too bad that women's liberation didn't occur thirty years earlier in my life. It would have been of enormous assistance at that time. I couldn't run out and do a one-woman job on the whole masculine art world and continue my paintings and stay in the role I was in as Mrs. Pollock. What I considered important was that I was able to do my work and other things would have to take their turn. Rightly or wrongly I made my decision!" (*Artforum*, vol. 12, no. 4, December 1973).

Palingenesis, 1971, Pollock-Krasner Foundation, New York

↖ *Portrait of Lee Krasner* by Fred Prater, *c.*1940, Smithsonian Institution, Archives of American Art, Washington, DC

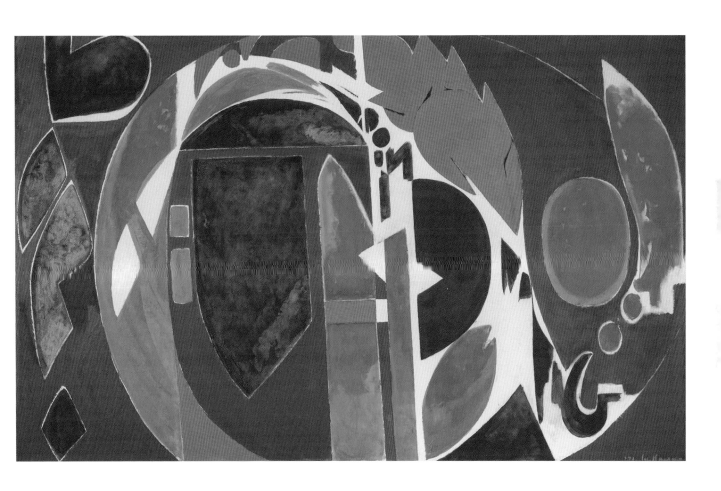

AURÉLIE NEMOURS

(1910–2005)

A major figure of concrete art, Aurélie Nemours (née Marcelle Baron) studied art history at the École du Louvre (1929–1932), then painting in the studios of the poster artist Paul Colin, André Lhote and Fernand Léger. She began exhibiting at the Salons in the 1940s. In 1949, at the Salon des réalités nouvelles, which specialized in non-figuration, her work was noticed by the show's cofounder, the artist Auguste Herbin. She had her first solo exhibition at the Galerie Colette Allendy in June 1953. Michel Seuphor, an important French theorist of abstraction, wrote the catalogue text and introduced her to the work of Piet Mondrian, which was a revelation for her. In this exhibition, she notably showed *Three Figures* (1952/1953, Museum Würth, Künzelsau), a key, programmatic picture in the evolution of her work with areas of solid colour and geometric shapes (rectangles, squares) emphasizing the picture's two-dimensionality. She continually pared down her painting in the service of composition and rhythm. Having first eliminated the human figure, from 1952 she abandoned signs and curved lines then, like Mondrian, the diagonal. She also reduced the number of colours used. In 1957, she joined Groupe Espace, founded by the painter Félix Del Marle, and in 1960 Groupe Mesure, created by the painter Georges Folmer. Between 1950 and 1960, she also produced engravings and collages.

Nemours worked in series whose titles, nonetheless, still had a foothold in reality: *Partages* ("Sharings"), *Échiquiers* ("Chessboards"), *Carrés couronnes* ("Squares crowns"), *Rosaces* ("Rose windows") and *Commotions du point* ("Shock of the point") in which the square dominates. Her work increasingly attracted the attention of galleries, collectors and museums, but macular degeneration forced her to abandon painting in 1992. The author of several books of poetry since 1950, she then devoted herself to writing. Always concerned with the question of monumentality, she was nevertheless able to design the stained-glass windows (1998) of the priory of Notre-Dame de Salagon in the Alpes-de-Haute-Provence in monochromatic red, and created her only sculpture, *Alignement du XXIᵉ siècle* (*Alignment of the 21st Century*; 2005), for the Parc de Beauregard in Rennes, comprising seventy-two Breton granite columns arranged according to the path of the Sun.

Commotion du point 12, 1971,
Musée d'Art moderne de Paris, Paris

GEGO

(1912–1994)

After earning a diploma in architecture in 1938, Gertrud Louise Goldschmidt left Germany for Venezuela the following year due to the Nazi persecution of the Jews. She adopted the pseudonym Gego, worked for several architecture firms and taught before devoting herself to her own work. Her landscape paintings inspired by life on the Caribbean coast were followed by geometric drawings structured with parallel lines, a procedure which she then transposed into sculpture (the series *Líneas paralelas* ["Parallel lines"], 1957–1971). In these painted metal pieces (e.g., *Esfera* [*Sphere*], 1959, Museum of Modern Art, New York), the idea of internal movement, linked to optical illusion, is essential – as in the case of kinetic art, to which Gego has sometimes been associated.

In the late 1960s, she took a greater interest in volume and its organic expansion in space with the series *Reticulárea* ("Area of tiny nets"; 1969–1982), a major contribution to the history of twentieth-century sculpture. These suspended compositions, which Gego compared to three-dimensional drawings, are composed of net-like cells of steel wire subjected to slight deformations that wave slightly in the surrounding currents of air. In this reflexion on volume and void, there are reminiscences of her initial training as an architect. She further explored this procedure in other series, such as *Dibujos sin papel* ("Drawings without paper"; 1976–1987), flat suspended sculptures in which colour is sometimes present. In the 1980s and 1990s, she created small steel wire pieces (*Bichitos* ["Creepy-crawlies"]) and drawings composed of strips of interlaced paper (*Tejeduras* ["Weavings"]): "There is no danger for me to get stuck", she explained during a workshop in 1966, "because with each line I draw, hundreds more wait to be drawn. That is the circle of knowledge with the ring around, you enlarge the inner circle and the outer becomes greater – no end" ("Testimony 4", in *Sabiduras and Other Texts* by Gego, Houston: Museum of Fine Arts, Houston, 2005). Although she began exhibiting in the 1950s, there was no major retrospective of her work until 2002, eight years after her death.

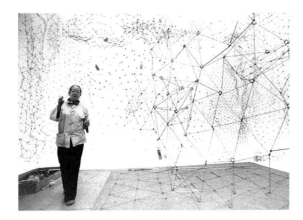

Reticulárea 1975, Museum of Fine Arts, Houston

↖ Gego assembling one of her works, 1980, Galería de Arte Nacional, Caracas

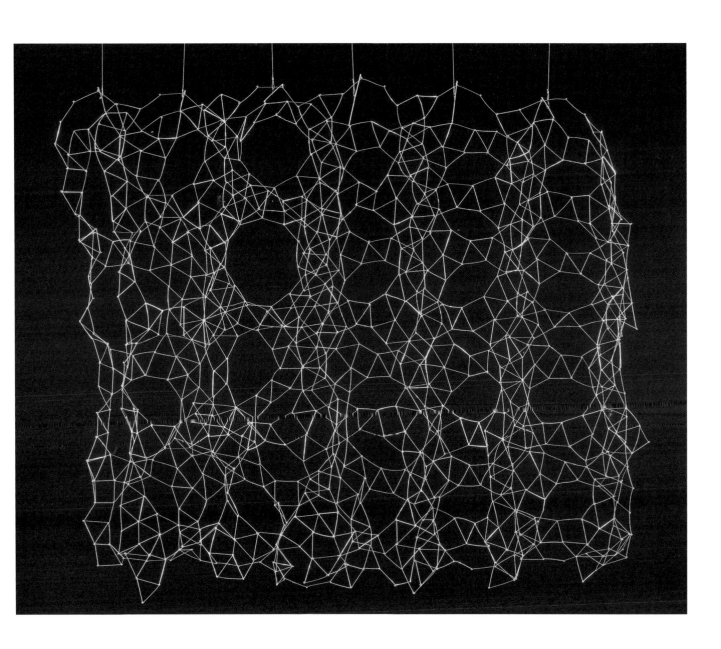

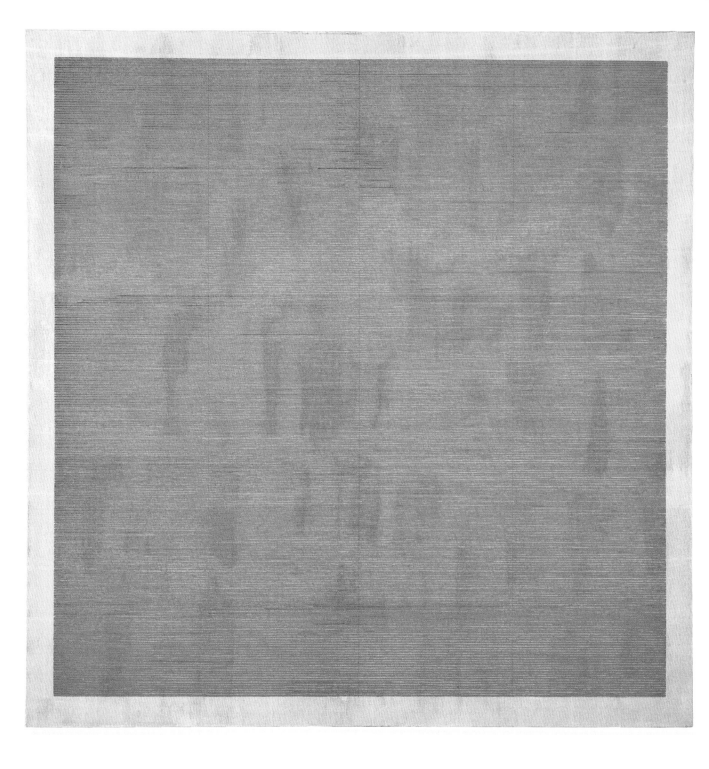

AGNES MARTIN

(1912–2004)

Born in Canada, Agnes Martin left for the United States when she was twenty to study painting and teach. Her first works, which she later disowned and partly destroyed, were influenced by cubism and surrealism. In 1957, she left New Mexico, after having lived there for ten years, for New York, where she befriended her artist neighbours Robert Indiana, Ellsworth Kelly and Lenore Tawney. She gravitated towards geometric forms, initially brightly coloured then later in subdued monochrome hues, and soon began using the grid as a means of conveying a spiritual, even metaphysical experience. As in *Falling Blue* (1963), each line, drawn in graphite then painted, vibrates with a unique sensation. This picture stimulates the viewer's thought with its uncommonly purified vocabulary. In 2002, for a documentary on her work by Leon d'Avigdor, Martin explained, "I am simply painting concrete representation of abstract emotions such as innocent love, ordinary happiness. I do want an emotional response. And I paint about emotions, not about lines. The truth is that it's not the lines that express the emotion. […] It's the space between the lines that counts."

Her works, which she preferred to be equated with abstract expressionism rather than the coldness of minimalism, attracted the interest of galleries and critics and were shown in several major exhibitions of the 1960s (e.g., *Geometric Abstraction in America*, Whitney Museum of American Art, New York, 1962; *The Responsive Eye*, Museum of Modern Art, New York, 1965). A serious personal crisis in 1967 caused her to stop painting and move back to New Mexico. When she began painting again in 1974, she abandoned the grid for vertical then horizontal bands, mostly grey. Her solitary nature marginalized her from the art world and her work was not rediscovered and fully appreciated until the beginning of the twenty-first century.

Falling Blue, 1963, San Francisco
Museum of Modern Art, San Francisco

ELIZABETH CATLETT

(1915–2012)

Inspired by the Harlem Renaissance, the revival of African American culture between the World Wars, Elizabeth Catlett studied with the painters Loïs Mailou Jones and Grant Wood before taking up sculpture and printmaking. *Mother and Child* (1939), a wood sculpture executed for her thesis at the University of Iowa, provided her with her first success at Chicago's *American Negro Exposition* in 1940. Motherhood, a recurrent motif in her work, was a means for her to explore the experience of Black American women in a country marked by racial segregation – she herself had been refused admission to the Carnegie Institute of Technology due to the colour of her skin. She portrayed women who are strong and determined despite the social difficulties and racism they faced.

Returning to New York after teaching at Dillard University in New Orleans, she met the sculptor Ossip Zadkine, who encouraged her to adopt simplified, geometricized forms. In 1945, a trip to Mexico and becoming acquainted with murals by artists such as Diego Rivera, José Clemente Orozco and David Alfaro Siqueiros stimulated her ambition to create an art for the people. Two years later, she moved permanently to Mexico, studied with Francisco Zúñiga and José L. Ruiz, and became the first female professor of sculpture at the National Autonomous University of Mexico. In Mexico, famous

for its popular woodcuts, Catlett learned linocut printing, regarding it as an ideal medium for disseminating a realist art accessible to all. Her use of the medium is exemplified by *Sharecropper* (1952), a lively portrait of an anonymous tenant farmer. The American Embassy's critical attitude regarding her ties with the Mexican Left prompted her to become a Mexican citizen before she was declared an "undesirable alien" by the State Department. However, this did not hamper her active commitment to the civil rights movement in the United States. Her work met with increasing success due to the wide circulation of her prints and her political activism. She explained to the art historian Samella S. Lewis, "I always wanted my art to service my people – to reflect us, to relate to us, to stimulate us, to make us aware of our potential" (*African American Art and Artists*, Berkeley: University of California Press, 2003).

Sharecropper, 1952,
Museum of Modern Art, New York

↑ *Portrait Of Elizabeth Catlett* by Fern Logan

44

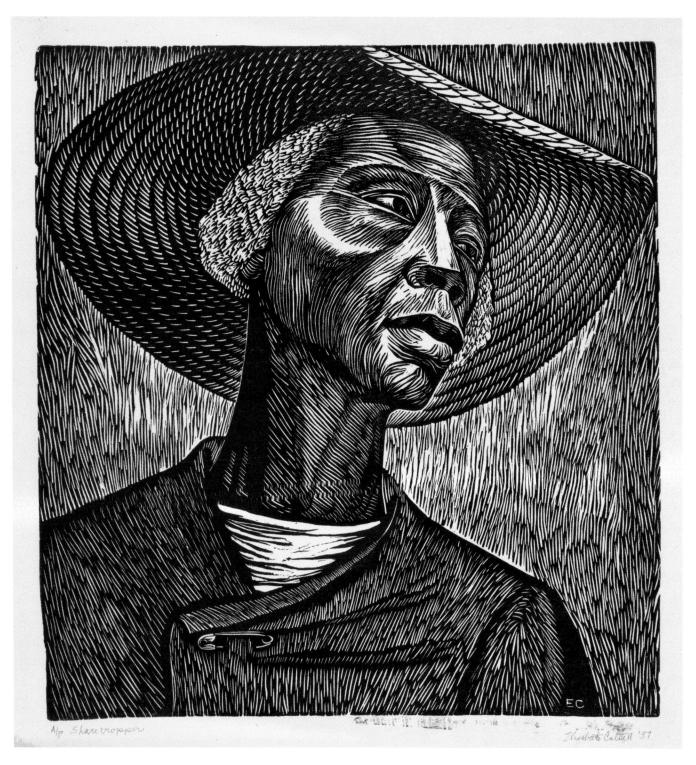

A/p Sharecropper Elizabeth Catlett '57

CARMEN HERRERA

(1915–2022)

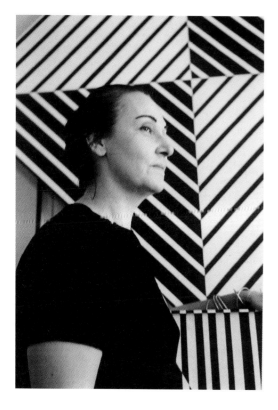

Blanco y Verde, 1959, Tate, London

↑ Carmen Herrera in front of *Black and White*, 1952, and holding *Quartet*, 1961

Little known until the 2000s, Carmen Herrera did not sell her first painting until she was eighty-nine. Yet she had been obstinately exploring the paths of abstraction for more than half a century. Living in Paris from 1949 to 1954, she showed several times at the Salon des réalités nouvelles, which specialized in non-figurative art. During this period, influenced by Kazimir Malevich and Piet Mondrian, she introduced lines and increasingly simplified geometric forms into her paintings and reduced her palette to three then two colours: "I like things very simple", she explained to *Artforum* in October 2016. "I never saw a straight line I did not like! My visual language is based on the idea of contrasts and on the juxtaposition of shapes. […] Colors are really intuitive. There is no formula. I like to juxtapose shapes and colors until they tell me to stop. Then I know I have a painting." This experimentation was contemporaneous with the emergence of what would be later known as "hard-edge painting" (e.g., Ellsworth Kelly, Frank Stella, et al.).

When Herrera moved to New York in 1954 her work received a cool reception from the American art world, then immersed in abstract expressionism. As Dana Miller – curator of the 2016 retrospective at the Whitney Museum of American Art in New York, which served as a late celebration of Herrera's work – emphasized, Herrera suffered from the dual discrimination of being both a woman and Cuban. Her work was shown only rarely (e.g., in the exhibition, *Women Choose Women*, New York Cultural Center, 1973), but she pursued her art steadfastly, notably in the *Blanco y Verde* series (*White and Green*; 1959–1971) synthetizing her conceptual and minimal aesthetic and integrating the medium and its surroundings into the work itself. The picture, thus, becomes a three-dimensional object, on which she painted coloured slices across the support intended to be shown on a white wall. The green triangles, differing from one picture to another, appear to cut into the surface and dissect the space (more rarely, she painted white triangles on a green ground). Herrera, who had studied sculpture and architecture in Havana, also produced equally incisive three-dimensional works.

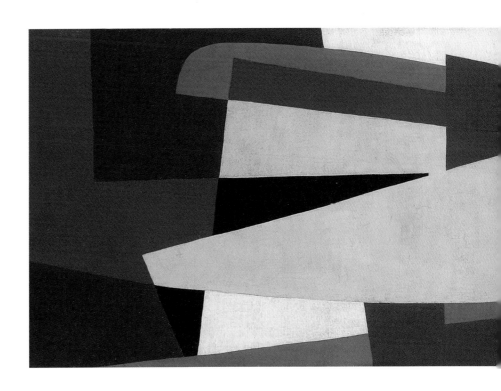

SALOUA RAOUDA CHOUCAIR

(1916–2017)

After graduating with a degree in natural sciences and working as a librarian, Saloua Raouda Choucair attended classes of the Lebanese painter Omar Onsi before enrolling at the École nationale supérieure des beaux-arts in Paris in 1948. In 1950, she joined the Atelier d'art abstrait and had her first solo exhibition at the Galerie Colette Allendy the following year.

She began working on her "geometric paintings", the beginning of her meditation on Islamic art and its non-figurative tradition transposed into simple, rhythmic shapes. *Composition with Two Ovals* (1951) is characteristic of Choucair's formal repertoire of straight and curved

lines and large areas of solid colour. In her view, the artistic realm should not be limited to the so-called "fine" arts but include artisanal crafts and be equally devoted to philosophical, spiritual and moral reflection. She also encouraged rooting abstraction in daily life and a liberation from European and American influences, opposing the Western concept of the autonomous artwork.

When she returned to Beirut in the early 1950s, Choucair was one of the first women to work there as an artist. She produced paintings and sculptures in vast series such as *Trajectories of a Line*, *Poems*, *Interform* and *Doubles*, largely

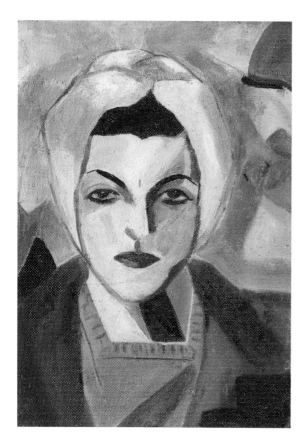

inspired by classical Arabic poetry and Sufi thought. She created a series of modular pieces in wood and stone. Like lyric stanzas, these modules may be viewed independently from one another or regarded as a whole. The same cellular organization exists in her paintings.

Intent on making her work more widely accessible and faithful to her global vision of creation, she also produced artefacts (e.g., knives, scarves, bags, jewellery) and furniture, as well as prints and monumental sculptures for public spaces. From the 1980s onwards, Choucair's work received increasing critical and institutional acclaim, both in Lebanon and internationally, but she had to wait until 2013 for her first major retrospective in the West (Tate Modern, London).

Composition with Two Ovals, 1951, Tate, London

↖ *Self-Portrait*, 1943, Saloua Raouda Choucair Foundation

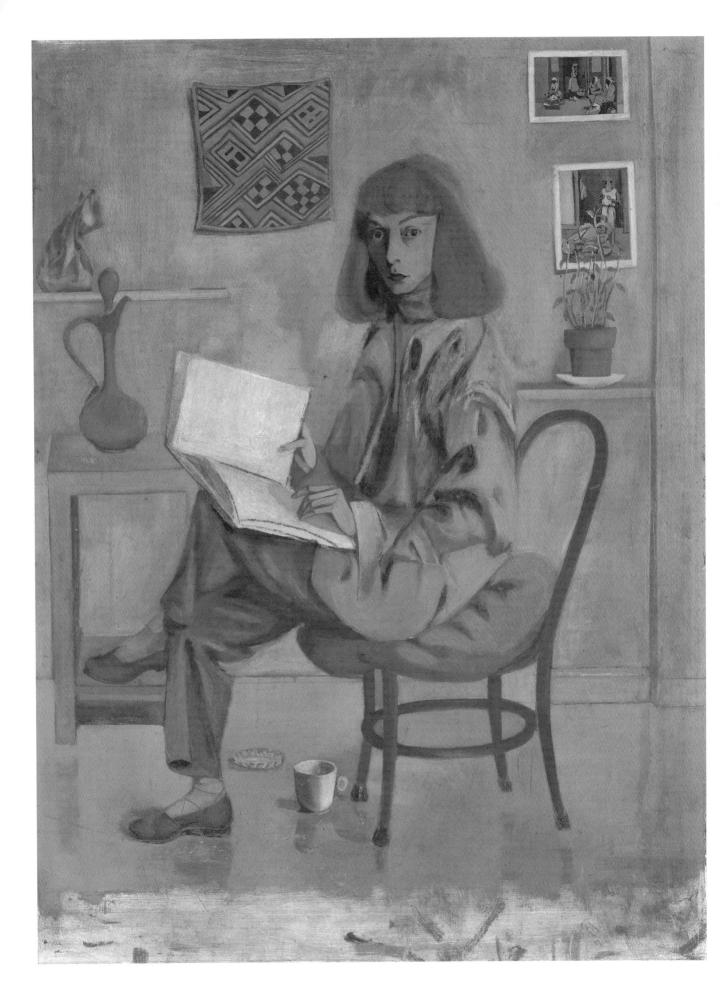

ELAINE DE KOONING

(1918–1989)

Elaine de Kooning (née Fried) studied painting and drawing, attending the courses of Josef Albers and, notably, those of her future husband, Willem de Kooning, at Black Mountain College before she herself began teaching. Although close to abstract expressionism, she differed from most of its representatives by combining abstraction and figuration. Her first self-portraits show her gift for drawing. Exemplary of this is *Self-Portrait #3* (1946) in which she portrays herself seated in her studio, sketchbook in hand, surrounded by carefully executed small works, seemingly as a nod to the rigorous teaching she received from Willem de Kooning.

Pursuing this path in the 1950s, she embarked on an important series of highly gestural portraits in which she combined a certain concern with likeness and a lively expressiveness of brushwork and colour. She painted her circle of friends and influential members of the New York art world before she received an official commission for the portrait of President John F. Kennedy (1963, Smithsonian Institute, National Portrait Gallery, Washington, DC). It was in the 1950s that she also showed in her first group exhibitions, including the *Ninth Street Show* organized by the Leo Castelli Gallery in 1951 and *Young American Painters*, a travelling exhibition organized by the Museum of Modern Art (1956–1958), while also having solo exhibitions at the Stable Gallery in 1953, 1954 and 1956. As a critic at the New-York-based magazine *ARTnews*, she wrote numerous articles on artists such as Arshile Gorky, Franz Kline, David Smith, Mark Rothko, Jackson Pollock and her former teacher Josef Albers.

Elaine de Kooning was fond of working on series, often for several years and whose titles emphasize their roots in "reality" (e.g., *Bullfights, Bacchus, Basketball Players*). Her encounter with Palaeolithic art during a visit to the caves at Lascaux in 1983 left a deep impression on her and inspired her last major series, *Cave Walls*, composed of animal paintings.

Self-Portrait #3, 1946, Smithsonian Institution, National Portrait Gallery, Washington, DC

VERA MOLNÁR

(1924–2023)

After studying at Budapest's School of Fine Arts, Vera Molnár (née Gács) permanently moved to France in 1947. There, she became acquainted with the works of Fernand Léger and Le Corbusier and, influenced by the theoretical contributions of the first generation of abstract artists (e.g., Kazimir Malevich, Piet Mondrian), she adopted a more radical, minimalist, geometricized and pared-down approach to painting. She became friends with painters and authors such as Michel Seuphor, Auguste Herbin, Jesús Rafael Soto, Sonia Delaunay and François Morellet.

In 1960, she helped found and was a brief member of the Centre de recherche d'art visuel (CRAV), which was promptly renamed Groupe de recherche d'art visuel (GRAV), whose research was notably focussed on kineticism and the importance of perception. At this time, she became interested in mathematics and inventing a painting style entirely controlled by what she termed the "machine imaginaire" (imaginary machine). But she soon became one of the first artists to create with the aid of a very real machine, a computer produced by Bull Information Systems. Using computer programming and algorithms, she placed the creative process at the heart of her work, liberating it from the traditional singularity ascribed to the painterly gesture. Yet, she continued to regard information technology as a tool that could never replace the artist.

She devised her first graphics generating software, Molnart (1974–1976), which utilized a plotter, in collaboration with Pierre Barbaud, a member of the Art et Informatique group (Institut d'esthétique et des sciences de l'art), and then developed a further programme, Resauto (1990s), which enabled her to repeat and reinterpret versions of a single work. Molnár explored an infinite number of variations and permutations that continue to raise questions concerning the challenges of perception. The series *À la recherche de Paul Klee* ("In search of Paul Klee"; 1970–1971), inspired by the chequerboard motif in Klee's *Variations (Progressive Motif)* (1927, Metropolitan Museum of Art, New York), explores the creative possibilities of the network and grid, notably while using a plotter.

Untitled, 1970, Musée national d'Art moderne, Centre Pompidou, Paris

↖ *100 Yellow Squares (Computer Icon 3)*, 1977, FRAC Normandie, Caen

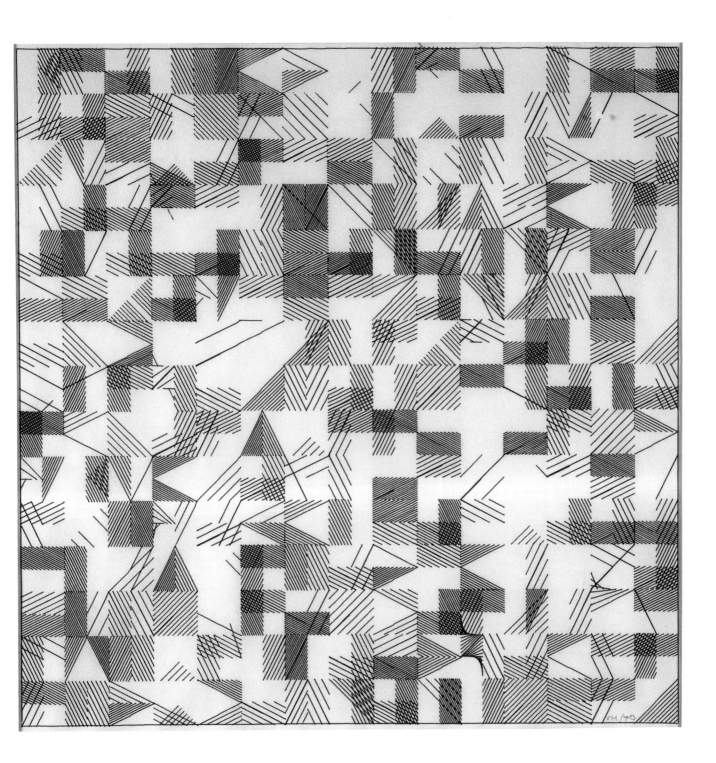

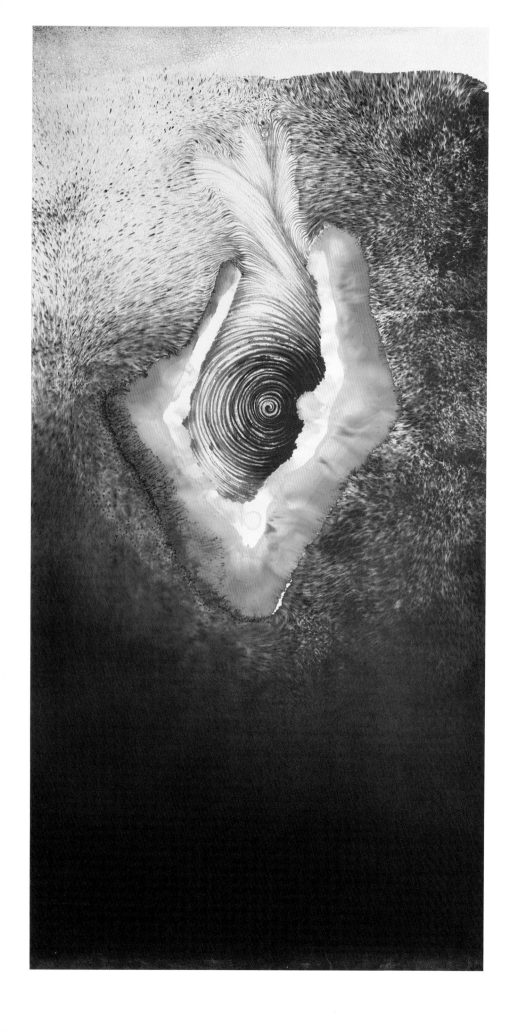

IRENE CHOU

(1924–2011)

Born in Shanghai, Irene Chou moved to Hong Kong in 1949, then a British colony on the verge of experiencing a massive cultural boom. From 1954, she studied the Lingnan style of painting (a nineteenth-century figurative style) with Chao Shao-an, then ink painting in 1966 under the guidance of Lui Shou-kwan, pioneer of the New Ink movement, a blend of Chinese pictorial traditions and contemporary Western artistic influences. In 1971, she took part in the creation of the One Art Group, a milestone movement in Hong Kong's art history.

Influenced notably by surrealism and abstract expressionism, but also by Taoist and Zen philosophy, Chou invented abstract and organic forms linked to female experience (e.g., pregnancy, childbirth) and the power of the cosmos. In *Movement II* (*c.*1985), she created a centripetal rhythm using different techniques: wet and dry inks combined in the lower part of the composition in contrast to the stippling, dots and swirling lines, not to mention the red ink wash, in the upper part.

She returned to this experimentation in the early 1990s when, convalescing after a stroke, she found new energy in qigong (a traditional system of physical exercise combining meditative movement and controlled breathing) and Chinese metaphysical thought. Then living in Brisbane, Australia, she began working in large formats using "impact structural strokes", her own individual technique that involved the violent application of ink to damp Xuan paper. At the same time, Chou began the very gestural and expressive *Universe Paintings* series in which she again explored the themes of the universe, the microcosm and spirituality.

*Movement II, c.*1985,
M+, Hong Kong

BERTINA LOPES

(1924–2012)

Bertina Lopes grew up between Mozambique, her mother's country, and Portugal, her father's country. During her stays in Portugal, she attended lessons by the painters Lino António and Celestino Alves before enrolling at the António Arroio School of Decorative Arts in Lisbon. She familiarized herself there with the European artistic and intellectual avant-gardes and adopted a solid political stance rooted in Marxism. In 1953, she went to live and teach at Lourenço Marques (renamed Maputo following Mozambican independence in 1975).

At the time, Lopes's painting was figurative, as illustrated by *Sto sognando? La città è questa?* ("Am I dreaming? Is this the city?"), an image of a woman thrilled by her vision of a city, a hope of freedom. Active in anti-colonial movements, notably with her first husband, the poet Virgílio de Lemos, in 1961 she was forced to leave Africa for Portugal, where a grant from the Calouste Gulbenkian Foundation enabled her to continue painting. At that time, she began combining Mozambican formal and iconographic influences with a new interest in line, deconstruction and a vivid palette. But the status of the female artist, frowned upon by the Salazar dictatorship, prompted Lopes to leave Lisbon for Rome in 1964 and obtain Italian citizenship the following year. She became acquainted with numerous artists, writers and art critics, including Marino Marini, Antonio Scordia and Renato Guttuso. Her work became more expressive and her figures more elongated or more compact. In the early 1970s, she became particularly fond of the cubism of Georges Braque and Pablo Picasso, which inspired her geometricized forms.

Portugal's transition to democracy in 1974 led to Mozambique's independence. The political instability this created is conveyed in Lopes's work by a violent use of colour and found materials (the *Totems* series). She alternated between abstraction and figuration and produced several sculptures. From then onwards, she showed regularly in Mozambique as well as in Europe. After her pictures of the 1980s and 1990s composed of organic lines and exploring cosmic motifs, Lopes turned to the questions of music, rhythm and colour dear to Wassily Kandinsky.

Sto Sognando? La Città è questa?, 1958, Smithsonian Institute, National Museum of African Art, Washington, DC

↖ Bertina Lopes in her studio in Maputo, 1986

NANCY SPERO

(1926–2009)

Nancy Spero originally trained at the School of the Art Institute of Chicago and then in André Lhote's studio at the École nationale supérieure des beaux-arts in Paris (1949/1950) before going on to create a highly influential figurative and feminist body of work. She moved to France in 1959 with her husband, the painter Leon Golub, and exhibited there often, less inhibited in Paris by her status as mother and wife, she said, than she had been in the United States.

Until the mid-1960s, Spero painted standing figures and embracing couples, often of indeterminate sex, such as *Lovers* (1962). This picture belongs to the series *Black Paris Paintings*, consisting of a layer of black painted on a gold oil ground on which the figures are sketched in with turpentine: "for many years I have returned to a double image which has assumed diverse forms […] existentially expressed through the inspiration of Tarot cards. This theme embodies a rapport, a contact of two beings in a ritual or sensual sense" (cited in *Nancy Spero*, exh. cat., London: Institute of Contemporary Arts, 1987, p. 122).

On her return to the United States in 1964, she devoted a series of 150 gouaches and ink drawings on paper, media she considered less "virile" than oil on canvas, to the Vietnam War (*War Series*), in which she notably transformed helicopters into insects and gave bombs human form. From 1969, she followed this series with two cycles paying tribute to Antonin Artaud and his drawings of the 1940s (*Artaud Paintings* and *Codex Artaud*). In parallel, she played an active role in the fight for female artists as a member of Women Artists in Revolution (WAR) and the Ad Hoc Women Artists' Committee, before cofounding the A.I.R. Gallery (Artists in Residence), the first cooperative exhibition space in New York dedicated solely to women.

Text, typography and the ideogram, inspired by ancient cultures, began to play an increasingly important role in Spero's work, and she also began to take an interest in collage. Concerned more than ever by political questions and the place of women within culture, she produced a series on the tortures inflicted on women in Nicaragua (*Torture of Women*, 1974–1976), then another on the role of women in history (*Notes in Time on Women*, 1976–1979). She later returned to painting, working in increasingly imposing formats (e.g., *Azur*, 2002, Musée national d'Art moderne, Centre Pompidou, Paris) as a homage to the tradition of monumental antique and medieval art.

LYGIA PAPE

(1927–2004)

Lygia Pape was taught etching by Fayga Ostrower and studied philosophy and aesthetics at the Federal University of Rio de Janeiro. In the early 1950s, she played a role in the effervescent Brazilian avant-garde art scene spearheaded by the concrete art movement. For the young generation to which Pape belonged, concrete art was a radical means of breaking with tropical "folk" painting, capable of embodying *brasilidade*, the quest for a national culture independent of Europe. She joined Grupo Frente, created in 1954 by Ivan Serpa, and produced a series of woodblock prints entitled *Tecelares* ("Weavings"; 1955–1959), composed of interlocking geometric shapes.

But this overly restrictive conception of abstract art led Pape to co-sign "The Neo-Concrete Manifesto" with Amilcar de Castro, Lygia Clark and Reynaldo Jardim in 1959. This document called for the abandonment of a cerebral and orthodox conception of abstraction in favour of a phenomenological approach based on the senses. From then on, Pape experimented with new forms of expression, combining experimental film, performance and sculpture. She also initiated numerous participatory projects, of which the first and one of the most striking is *Divisor* ("Divider"; 1968). In Rio de Janeiro, beneath an enormous 30 × 30 m piece of fabric, she brought together hundreds of people from different neighbourhoods of the city. Through the openings cut into the sheet, the participants are able to poke their heads out. In an urban setting, literally embodying the "social fabric", the sheet abolishes the class relations indicated by the bodies and class markers hidden beneath: body size, clothes, accessories, etc. are effaced in joyous union. It also enabled the artist and participants to creatively appropriate the city, to breathe a certain poetry and their own dynamism into it. This performance may be reconstructed at will, including in Pape's absence, thereby questioning the centrality of the author and their authority.

Pape had her first major solo exhibition at the Museu de Arte Moderna of Rio de Janeiro in 1976. She then turned to architecture and urbanism as a means of reflecting on power relations (male/female, rich/poor, etc.) at work in Brazilian society (e.g., *Eat Me*, 1975). Her increasing international recognition did not diminish her social commitment, as shown by *Carandiru* (2001), an installation evoking the massacre of 111 inmates in a Brazilian prison.

Divisor, 1968, performance with children at the Museu de Arte Moderna do Rio de Janeiro

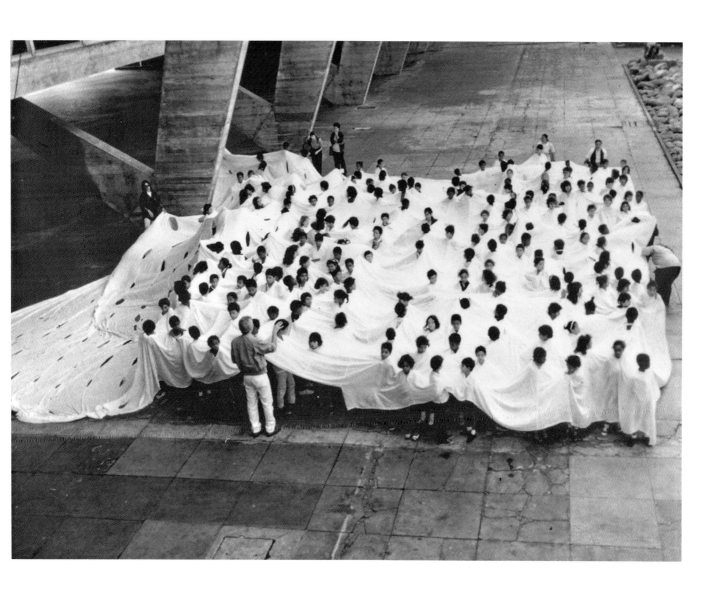

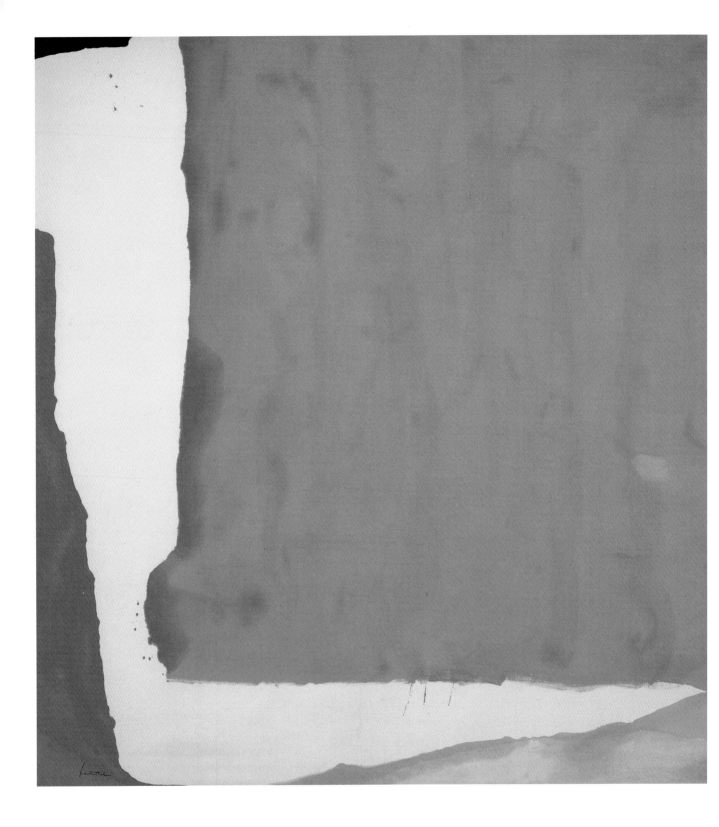

HELEN FRANKENTHALER

(1928–2011)

Helen Frankenthaler is one of the principal figures of abstract expressionism. She first studied painting with Rufino Tamayo at the Dalton School in New York and then with Paul Feeley at Bennington College in Vermont before meeting Clement Greenberg and the New York artists of the time, including Lee Krasner, Elaine and Willem de Kooning and Barnett Newman.

In the early 1950s, she invented the "soak-stain" technique of painting: on a loose sheet of canvas spread on the floor, she applied paint diluted with turpentine, which soaked like dye into the unprimed fabric. This opened a new path within abstract expressionism: "colour field painting". Although with less heroic connotations than Jackson Pollock's "drip technique" or Franz Kline's gestural approach, it was notably adopted by Morris Louis and Kenneth Noland. Frankenthaler later used layers of often contrasting and increasingly nebulous colours, which filled the entire canvas. She was also an inventive printmaker, particularly in her woodcuts, and played an active role in the revival of printmaking in the United States. From the 1950s, she showed regularly in galleries and had a retrospective at New York's Jewish Museum in 1960.

Like most of the abstract expressionists, Frankenthaler regarded the flatness of the picture surface as a shield against the pictorial illusionism inherited from the Renaissance and a pointed use of colour as a means of solidifying this surface. But unlike some of her counterparts, she never abandoned references to the "real" or, above all, nature. In 1969, she wrote about *Mauve District* (1966): "It relates to a theme which appears on-and-off, of pictures that often have one central vast shape, district, or territory; in this case, the shape itself (a square) is a play on the very shape of the canvas."

Mauve District, 1966,
Museum of Modern Art, New York

↑ *Helen Frankenthaler in Her Studio on West End Avenue, New York*, 1956, photographed by Gordon Parks for an article in *Life*, 13 May 1957

JACQUELINE FAHEY

(born 1929)

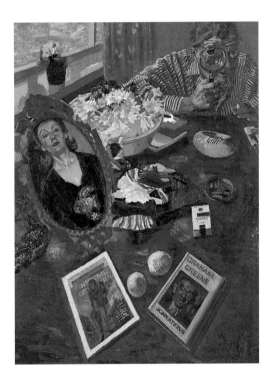

In her youth, Jacqueline Fahey's multilingual grandmother and professional pianist mother were important female role models. At the Canterbury College School of Art in Christchurch, she trained with Russell Clark, Bill Sutton and Colin Lovell-Smith and was one of the first women artists in New Zealand to have a professional career. Intent on seeing women better represented in the art world, in 1964 she and Rita Angus organized an exhibition in Wellington in which artists of both genders were equally represented. During a stay in the United States in 1980, she became acquainted with the A.I.R.

Gallery (Artists in Residence), the first cooperative women's art gallery in the United States, cofounded by Nancy Spero. Fahey herself benefited from the support of the Women's Gallery in Wellington.

Fahey seeks to convey the female experience and its specificities, often painting themes from the everyday with critical realism, working not in a studio but at home. Unsurprisingly, the quotidian duties of a housewife formed one of her favourite subjects. Influenced by the golden age of Flemish painting, she fills her pictures with details and decorative motifs suggesting domestic alienation; washing up, laundry, teas for the children and mother-daughter arguments, or those between sisters, become compositional subjects.

In *Fraser sees me, I see myself* (1975), Fahey focusses on the gaze: her own gaze on herself and the gaze of her husband, the famous psychiatrist Fraser McDonald, on her. The artist is looking at herself in a small mirror – we see only her reflection – while in the background, her husband's eye, enormously enlarged by a magnifying glass, examines her with scientific precision. On the right, before McDonald, there is a biography of the novelist Graham Greene by John Atkins, and next to Fahey's reflection on the left there is the October 1975 issue of *National Geographic*, on the cover of which we can see a young woman with orangutans. According to the art critic Bronwyn Lloyd, this is an allusion to the persistent stereotype associating men with culture and women with nature.

Georgie Pies for Lunch, 1977, Collection of Philippa Howden-Chapman and Ralph Chapman, Wellington

↖ *Fraser sees me, I see myself*, 1975, Museum of New Zealand Te Papa Tongarewa, Wellington

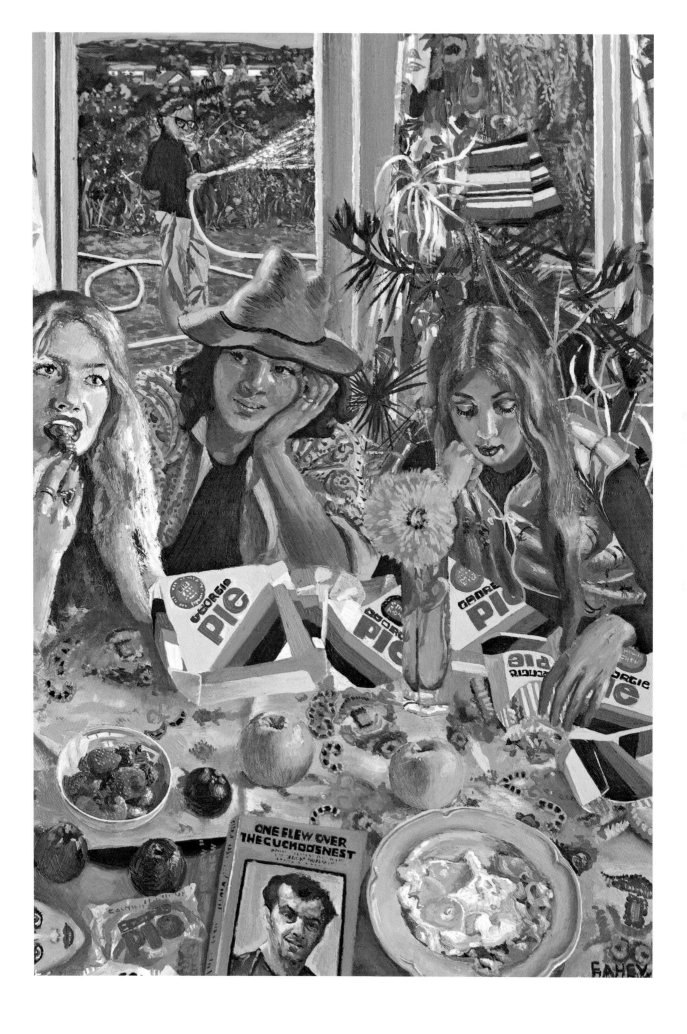

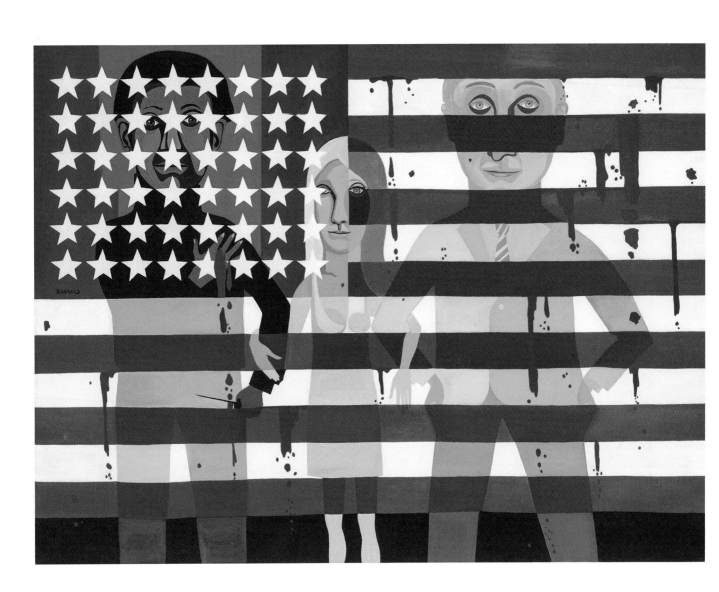

FAITH RINGGOLD

(born 1930)

After graduating from the City College of New York, the first free public institution of higher education in the United States, Faith Ringgold travelled in Europe in the early 1960s. When she returned home, she produced her first politically motivated works (*Black Light Series*, 1967–1969), a concern she has pursued all her life.

From 1963 to 1967, she painted *The American People Series*, twenty pictures depicting and criticizing the American way of life as the civil rights movement was gaining momentum. *The American People Series #18: The Flag Is Bleeding* (1967), one of the most important works in the cycle, presents three figures partly concealed by the American flag. On the left, an African American man wearing a turtleneck sweater is wounded in the area of his heart. With one hand, he holds the wound shut, while with the other, he grips a bloodstained knife. A white man in a suit stands on the right. In the middle, a prettily dressed white woman stands arm in arm with both men. Whereas one is risking his life fighting for his liberties, the others seem indifferent to his struggle, blinded by the myth of the American Dream. The flag, as if it had a life of its own, is also bleeding, signifying the social drama tearing America apart.

In the 1970s, Ringgold began to vary her artistic practice, drawing on multiple inspirations such as thangkas, rolls of painted fabric borrowed from Tibetan art, and then masks influenced by the ancient arts and rituals of Nigeria and Ghana (e.g., *Nigerian Face Mask #1*, 1976, Ballard Institute and

Museum of Puppetry, Mansfield). In 1980, she took up the time-honoured tradition of quilting to create textile pictures in which she incorporates texts (e.g., *Who's Afraid of Aunt Jemima?*, 1983, Glenstone, Potomac) and soon devoted herself exclusively to this medium, combining embroidery with painting in acrylic.

From the late 1960s, she campaigned in the feminist movement, notably to defend the place of women artists and combat the racist stereotypes endured by African Americans. Beginning in the 1980s, her work has been acclaimed by critics and museums, and she has received numerous awards.

The American People Series #18:
The Flag Is Bleeding, 1967, National
Gallery of Art, Washington, DC

↗ *The American Collection #1:*
We Came to America, 1997,
Pennsylvania Academy of the Fine Arts,
Philadelphia

67

MARISOL

(1930–2016)

Born into a wealthy Venezuelan family in France, María Sol Escobar, known as Marisol ("sea and sun"), a nickname she adopted in her youth, studied at the École nationale supérieure des beaux-arts in Paris and at the Art Students League in New York before joining the studio of Hans Hofmann, the Bavarian-born painter who trained numerous abstract expressionists, including Lee Krasner, Helen Frankenthaler and Robert De Niro, Sr.

In 1954, influenced by Pre-Columbian art, she modelled clay figurines and then cast bronze statuettes. In the early 1960s, Marisol executed her first "totemic" sculptures in wood, pared down, hieratic and often socially satirical creations in which painted anatomical elements carved in wood or plaster emerge from rectilinear blocks of wood – a leg, an ear and faces with several sides – to which she sometimes added mundane accessories (a hat, a pram, an umbrella, etc.). In them, she depicted the peculiarities and failings of American society, its norms and misogyny. In *Self-Portrait* (1961/1962), seven more or less caricatural heads, a pair of breasts and six legs emerge from a large block of wood. Some of the elements are in plaster (parts of the faces and feet). This heterogeneous, absurd self-portrait apes the different roles assigned to women in a country dominated by mass culture.

Marisol frequented Andy Warhol's Factory and rapidly met with success on the New York art scene. Her works were shown in prestigious galleries: the Leo Castelli Gallery, the Stable Gallery and the Sidney Janis Gallery. In 1968, she represented Venezuela at the Venice Biennale and was one of only four female artists (out of 145) selected for documenta 4 in Kassel. In the 1970s, she used sculpture in wood for her portraits paying tribute to politicians and major artists (e.g., Pablo Picasso, Willem de Kooning, Martha Graham, Marcel Duchamp, Georgia O'Keeffe). In the following decades, she returned to increasingly social subjects before beginning a series of sculpted portraits of Native Americans. She has also left us a wealth of works on paper.

Self-Portrait, 1961/1962,
Hammer Museum, Los Angeles

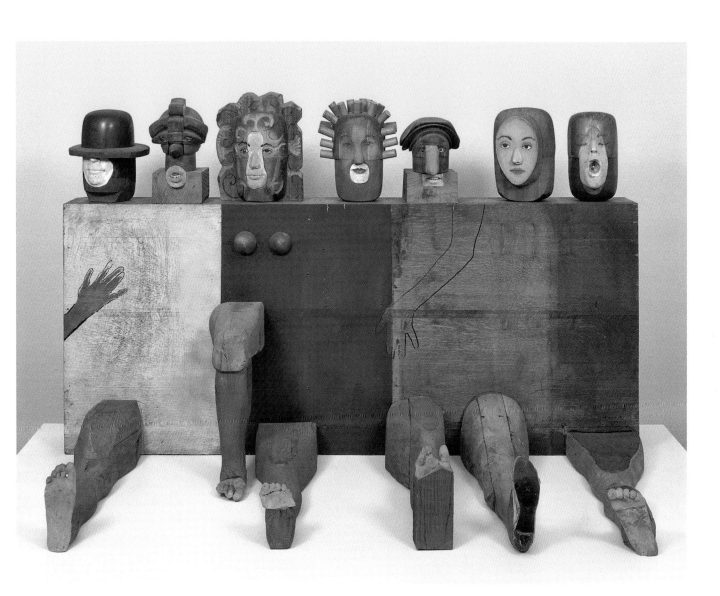

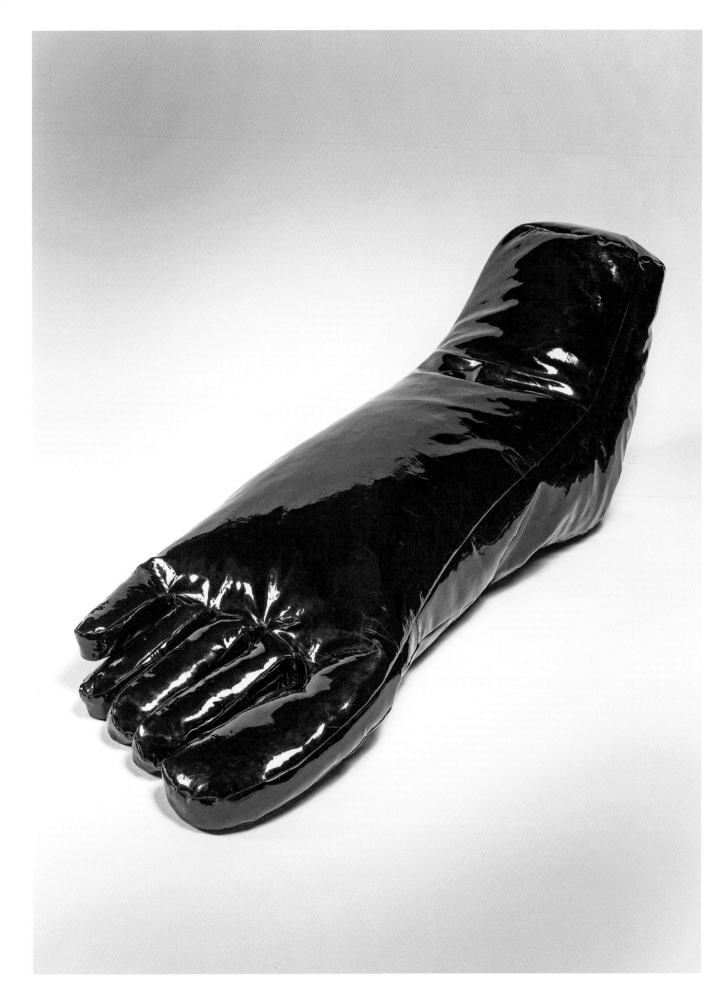

NICOLA L.

(1937–2018)

Nicola L., born Nicola Leuthe, trained in the studio of the painter Jean Souverbie before embarking on a multidisciplinary career as a sculptor, designer, performance artist, author and film director. She began as an abstract painter but destroyed her pictures in 1965 when her friend Alberto Greco committed suicide in an act he treated as a work of performance. She subsequently became close to the art critic Pierre Restany and the group of artists who labelled themselves the nouveaux réalistes.

The leitmotif of her oeuvre, the body – particularly the female body – is penetrated in works in which viewers are invited to insert their head or arms, or even their entire body (*La Chambre en Fourrure* ["The fur room"], 1969), or they serve as seats (e.g., *The Giant Foot*, 1968) or else decorate their interiors (e.g., *The Eye Lamp*, 1969). Her *Pénétrables* pieces (the title was coined by Restany) and functional sculptures, attractive as they are, emphasize the objectification of women in consumer society and their assignation to the domestic sphere. In *Little TV Woman: "I Am the Last Woman Object"* (1969), the woman-television declares: "I am the last woman object. You can take my lips, touch my breasts, caress my stomach, my sex. But I repeat it. It is the last time." The body is also a component of the social fabric, a reality to which Nicola L. gives form in *Red Coat* (1969), a

The Giant Foot, 1968, Musée national d'Art moderne, Centre Pompidou, Paris

↗ Portrait of Nicola L. with *La Femme commode*, 2015

huge raincoat worn by eleven people. She staged this collaborative performance in the streets of London, Brussels, Cologne, Paris and New York. She had her first solo exhibition in 1969 at the Galerie Daniel Templon in Paris.

From the 1970s onwards, Nicola L. made numerous films, including *Eva Forest* (1979) and *Bad Brains at CBGB* (1980), putting her creation of sculptures and objects to one side until the middle of the following decade. She left Paris and Ibiza to live in New York in 1979, where she also wrote several performance pieces, which she staged at the La MaMa Experimental Theatre Club. She had to wait, however, until the 2000s for many of her works to be rediscovered and again exhibited. Recently, several of them were shown in two major exhibitions re-evaluating pop art outside English-speaking male circles: *The World Goes Pop* (Tate Modern, London, 2015/2016) and *She-Bam Pow POP Wizz ! Les Amazones du POP* (MAMAC, Nice, 2020/2021).

71

ZARINA

(1937–2020)

The daughter of a lecturer at Aligarh Muslim University and a stay-at-home mother, Zarina – born Zarina Rashid, later Hashmi – initially studied mathematics. After she married a diplomat in 1958, she learned printmaking in the various cities where he was stationed, at Silpakorn University in Bangkok and then from 1963 in Stanley William Hayter's famous Atelier 17 in Paris.

The main themes of her work focus on the separation from her native land and its fragmentation, which she extended beyond her own painful memory of India's partition in 1947 and her Muslim family's hurried departure for Karachi, Pakistan, to that of all emigrants. Cartographic maps (e.g., *These Cities Blotted into the Wilderness*, 2003), routes, real or imaginary houses (e.g., *Homes I Made / A Life in Nine Lines*, 1997), faults and frontiers (e.g., *Dividing Line*, 2001), sometimes accompanied with texts in Urdu (e.g., *Letters from Home*, 2004) are recurrent motifs, depicted with refinement and minimalism inspired by Islamic decorative art. Poetry also plays an important role in her work.

In 1974, Zarina spent a year in Japan to learn traditional woodblock printing techniques. She also learned the principles of paper production, experimenting with a sculptural approach to this medium whose fragility, which she associated with skin, became an integral part of her work.

After her husband's death in 1977, she settled in New York, frequented feminist circles and began signing her work solely with her given name to liberate herself from patriarchal tradition. She taught at the New York Feminist Art Institute and in 1980, with Ana Mendieta and Kazuko Miyamoto, curated *Dialectics of Isolation: An Exhibition of Third World Women Artists of the United States* at the A.I.R. Gallery (Artists in Residence) cofounded by Nancy Spero. Yet her work was not widely recognized until the 2000s, when it was acclaimed in several exhibitions, notably in the United States and Great Britain.

Untitled, 2017, Tate, London

JUDY CHICAGO

(born 1939)

Judy Chicago is one of the principal figures of American feminist art. After graduating from the University of California, Los Angeles (UCLA), she showed her first minimalist sculptures at the major *Primary Structures* group exhibition presented by New York's Jewish Museum in 1966. Very critical of formalism and the male domination of the art world, from 1968 to 1974, she produced a series of some thirty environmental performances whose prime ambition was to "feminize the atmosphere" with coloured smoke erupting from fireworks modifying the landscape. From 1970, she developed the Feminist Art Program at Fresno State College and then pursued this line of experimentation with the artist Miriam Schapiro at the California Institute of the Arts (CalArts). With their students, they created the *Womanhouse* (1972), an amalgam of seventeen collaborative projects. In parallel, she and Schapiro developed a new, vaginal iconography, which they saw as the "kernel" of female experience. This approach, deemed essentialist, was controversial in feminist circles.

In 1973, with the graphic designer Sheila Levrant de Bretteville and the art historian Arlene Raven, Chicago founded an alternative art school, the Feminist Studio Workshop in the Woman's Building of Los Angeles. She became famous for *The Dinner Party* (1974–1979), a vast installation paying tribute to great women in history. On three long tables laid for dinner and arranged in a triangle, there are thirty-nine place settings modelled and crafted by the artist and assigned to an assortment of goddesses, biblical figures, writers, artists, etc., ranging from Sappho and Georgia O'Keeffe to Artemisia Gentileschi and Sacajawea. Each plate, for example Virginia Woolf's, is a three-dimensional object which, in the form of a flower or butterfly, evokes a stylized vulva. In the 1980s, Chicago chose to work in series (e.g., *Birth Project*, 1980–1985). The 140 drawings in *Autobiography of a Year* (1993/1994) reveal the intimacy of work in the studio, the freedom to question, experiment and doubt. In *The End: A Meditation on Death and Extinction* (2012–2018), she examines disappearance: her own and the massive extinction of wildlife. From the 2000s, a re-evaluation of her art and her theoretical contribution prompted numerous exhibitions in the United States and Europe.

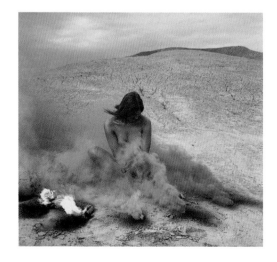

Virginia Woolf Place Setting, for
The Dinner Party, 1974–1979,
New York, Brooklyn Museum

↗ *Immolation IV*, 1972, from the series
Woman and Smoke, performance with
Faith Wilding in the Californian desert

VALIE EXPORT

(born 1940)

In the 1960s, VALIE EXPORT was one of the first artists to use her body to reflect on female alienation. The founding act in her oeuvre was her choice of a pseudonym conceived as a rebellion against the patriarchal society in which women bear the family name of their father, then that of their husband. In 1967, Waltraud Lehner rejected her civil status and associated her nickname, Valie, and the word Export (both written in capital letters like a logo) with its encouraging connotations of transmission.

The following year, VALIE EXPORT created *Identitätstransfer* (*Identity Transfer*). In these three self-portraits, although her overall appearance and clothing are masculine, her gentle face and very sixties-style makeup are traditionally feminine. These images exude a profound ambiguity at the very time when Western youth culture was blurring the distinctions between the sexes. And it is precisely in this ambiguity, in this singular staging of the body and the act of seduction, in this scrambling of the image of dominator and dominated, in this "identity transfer" that VALIE EXPORT shows the mechanisms of the objectification of women. *Identitätstransfer* is one of her most famous works, along with the performance *Action Pants: Genital Panic* (1969), staged in a pornographic cinema in Munich, in which she brandishes a machine gun while wearing jeans cut-out at their crotch to reveal her genitalia.

In the 1970s, VALIE EXPORT pursued this vein of social criticism by subverting images and seizing the media driving the mass dissemination of sexism (photography, cinema, television, etc.). For the series *Körperkonfigurationen* (*Body Configurations*; 1972–1976 and 1982), she poses in the streets of Vienna so that her figure seems to merge with urban or architectural elements, showing the extent to which the female body is structured by society. From the 1990s onward, her works became less overtly militant and more disillusioned in numerous installations and sculptures, such as *Fragmente der Bilder einer Berührung* (*Fragments of Images of a Touch*; 1994) in which eighteen light bulbs are slowly immersed in different liquids to symbolize disembodied relationships. During this period, she had numerous retrospectives in American and European museums.

Identitätstransfer 1–3, 1968,
Museum of Contemporary Art,
Los Angeles

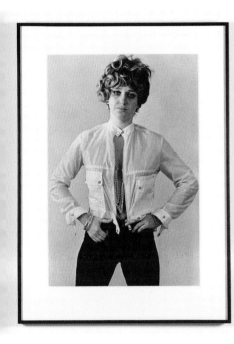

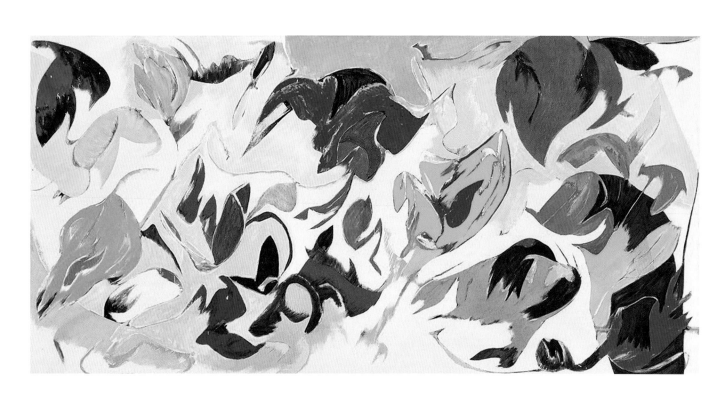

WOOK-KYUNG CHOI

(1940–1985)

Born into a cultured family, Wook-kyung Choi was taught by the painters Kim Ki-chang and Park Rehyun before attending the College of Fine Arts at Seoul National University. In Korea in the 1960s, which was dominated by Dansaekhwa (something of a meditative monochrome aesthetic), she was influenced by abstract expressionism after first seeing the work of Jackson Pollock.

Suffering the difficulties of a woman being an artist, Choi emigrated to the United States in 1963 to pursue studies at the Cranbrook Academy of Art in Detroit and then at the Brooklyn Museum Art School. Although art was more accessible to women there, the American art world was no less misogynous. Influenced by the work of Willem de Kooning, Franz Kline and Mark Rothko, Choi deepened her knowledge of abstract expressionism and also produced collages and pastels (e.g., *Who Is the Winner in This Bloody Battle?*, 1968, Kukje Gallery, Seoul) more rooted in reality and in which she could thus express her political stance against war and racism.

In the 1970s, Choi's palette mellowed and her forms became more organic, as in *Ecstasy* (1977): "My experiences, as a woman and a painter, serve as a daily source for the creative inspiration necessary for my work. My paintings are collaged bits of time from my past and present experiences. Each work has its own life as the forms grow and I convey my feelings into a visual language. My paintings are about my life but I am not simply telling stories. I am trying to express, visually, my experience of the moment lived. I hope to share, to communicate, and to create an empathy for the experience." Choi regularly exhibited in the United States and in South Korea. On her return to Korea at the end of the decade, she taught at Yeungnam University in Gyeongsan and then at Duksung Women's University in Seoul, where her focus shifted to figurative motifs and their decorative potential as well as landscape. She died prematurely, aged forty-five.

Ecstasy, 1977, National Museum of
Modern and Contemporary Art, Seoul

MARTHA ROSLER

(born 1943)

Martha Rosler is a political artist. Since the 1960s, she has reflected on the role of the image in mass culture and in the American collective subconscious. After graduating from the University of California, San Diego (UCSD) – a hotbed of the New American Left with the philosopher Herbert Marcuse as its focal point – she rapidly gave up painting for video and collages of photographs published in the press. She appreciated these media for their direct relationship to the production of images in industrial society but also for their accessibility compared to traditional means of artistic dissemination: e.g., galleries and museums.

Following the *Body Beautiful, or Beauty Knows No Pain* series of photomontages (*c.*1966–1972), she subverted advertisements and fashion and erotic photographs in order to highlight the objectification of the female body and the expectations weighing on it. In another series, *House Beautiful: Bringing the War Home* (*c.*1967–1972), Rosler juxtaposed graphic images of the Vietnam War and photographs from an interior decorating magazine, emphasizing the ambiguity of the United States, between imperialism, militarism and the myth of the American Dream. She updated the series (2004–2008) during the Iraq and Afghanistan wars.

In the mid-1970s, Rosler furthered her investigation of male dominance in hard-hitting video works. In *Semiotics of the Kitchen* (1975), a parody of a cooking programme and one of her most famous works, she is filmed in a kitchen in a single shot presenting the objects surrounding her by emphatically and even angrily miming their use. In the performance *Martha Rosler Reads Vogue* (1982), broadcast on a public-access cable network, she juxtaposes the glamour pages of a magazine and views of Chinese women working in the secret sweatshops of New York in a scathing criticism of the fashion industry. In 1983, she began work on a series of photographs, *In the Place of the Public: Airport Series*, still in progress, on the themes of transition and borders. In *Rights of Passage* (1995–1998), she pursued this reflection on an urban scale, photographing transport infrastructure between Brooklyn and New Jersey. In the installation *Invisible Labor* (2011), she focused on undocumented African labourers and sex workers and their immigration and trafficking in Eastern Europe.

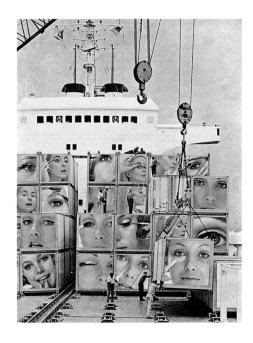

Semiotics of the Kitchen, 1975

↖ *Cargo Cult*, from the series *Body Beautiful, or Beauty Knows No Pain*, *c.*1966–1972

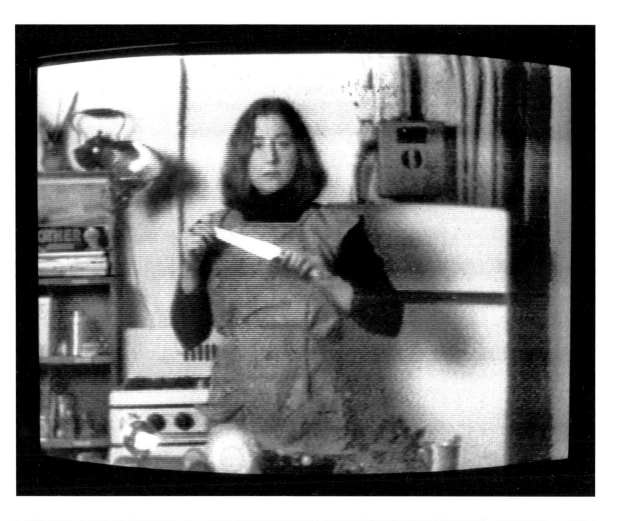

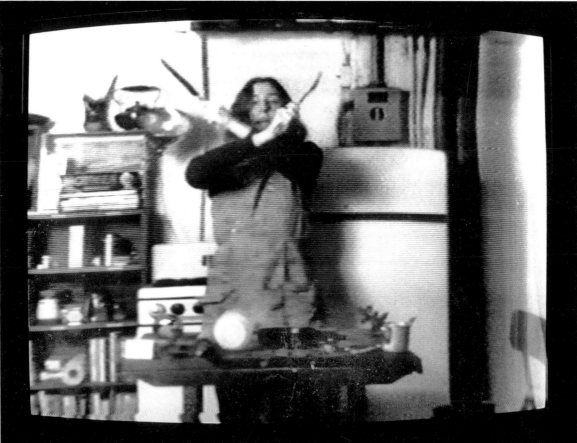

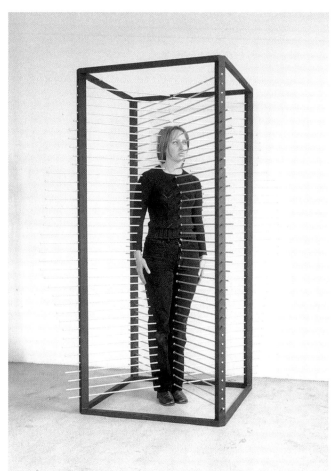

REBECCA HORN

(born 1944)

A graduate of Hamburg's University of Fine Arts (HFBK Hamburg), Rebecca Horn placed the body at the heart of her work, at the intersection of body art, performance art and video art. A long stay in a sanatorium to recover from severe lung damage, the result of working with toxic materials when she was a student, inspired the iconography of the prothesis, excrescence and metamorphosis recurrent in much of her work. She has infused this imagery with visual influences borrowed from dada and surrealism, literature (e.g., Franz Kafka, Jean Genet, Raymond Roussel) and cinema (e.g., Luis Buñuel, Pier Paolo Pasolini). For her performance *Einhorn* (*Unicorn*; 1970), she created a unicorn costume, worn by one of her fellow students, whom she filmed walking in a field like an apparition, emphasizing the fragility of the human body and the female quest for another social, political and physical reality.

In the 1980s, she produced moving sculptures with visible mechanisms and imbued with a spiritual dimension, such as *Pfauenmaschine* (*Peacock Machine*; 1979/1980). The automatic rhythm of the body and the anthropomorphism of the machine blend to prompt an intense reflection on binary concepts such as human/animal, animate/inanimate, interior/exterior, natural/artificial, male/female and subjective/objective.

In the 1980s and 1990s, Horn created installations exploring the question of the memory of places. In the permanent installation *Das gegenläufige Konzert* (*Concert in Reverse*; 1987–1997), set in the ruins of a defensive tower in Münster where the Nazis executed numerous prisoners, hammers beat the walls and ceilings as water drips into a basin from an enormous glass funnel, with snakes in a terrarium and an egg suspended between two metal pins evoking death and violence and the fascination they exercise on us. In recent decades, Horn has worked with light and mirrors (*Mondspiegel* [*Moon Mirror*], 2003). Since the 1980s, she has had numerous retrospectives in Europe and the United States.

Weisser Körperfächer, 1972, and
Messkasten, 1970, Rebecca Horn
Workshop

ANA MENDIETA

(1948–1985)

When she was twelve, Ana Mendieta was sent to the United States from Cuba with her elder sister by her parents for political reasons. She studied art under the instruction of Hans Breder at the University of Iowa, and her first feminist performances date from 1972–1974. In *Chicken Movie, Chicken Piece* (1972, Musée national d'Art moderne, Centre Pompidou, Paris), she stands naked holding a freshly decapitated, still convulsing chicken, an evocation of certain Catholic and pagan purification rituals but also the recurrent association of women and nature. In *Untitled (Facial Cosmetic Variations)* (1972, Museum of Modern Art, New York), she changes her appearance with makeup and wigs and reflects on the perception of the female identity and image.

In the mid-1970s, all her performances were set in nature, which she unwaveringly associated with femininity and in which she also explores the themes of being torn from her mother and Cuba, and the fusion of the microcosm and the macrocosm: "My exploration through my art of the relationship between myself and nature has been a clear result of my having been torn from my homeland during my adolescence. […] It is a way of reclaiming my roots and becoming one with nature.

Although the culture in which I live is part of me, my roots and cultural identity are a result of my Cuban heritage" (cited in Coco Fusco, ed., *Corpus Delecti: Performance Art of the Americas*, London: Routledge, 2000, p. 131).

For ten years, Mendieta did a great many performances in the United States, Havana and Canada. Among these, the *Siluetas* series (1973–1980) in which she used earth, blood, fire and water, is an inventive mixture of land art and performance. She enacted the first in this series at Yagul, Mexico, on the site of an Aztec tomb overgrown with vegetation on which she lies naked with her body covered with white flowers: "The analogy was that I was covered by time and history" (Mendieta in an interview with Linda Montano, in *Sulfur*, no. 22, spring 1988, p. 66). From 1971 to 1981, she also made 104 films.

In New York, where Mendieta lived from 1978, she was a member of the A.I.R. Gallery (Artists in Residence), the feminist exhibition space cofounded by Nancy Spero. She later lived for two years in Rome, where she created sculptures in burnt wood and clay. In 1985, she died after falling from a high-rise window in controversial circumstances. Her husband, the artist Carl Andre, was accused of having pushed her but was acquitted in 1988 on insufficient evidence.

Imagen de Yagul, 1973, from the series *Silueta Works in Mexico*, Museum of Contemporary Art, Los Angeles

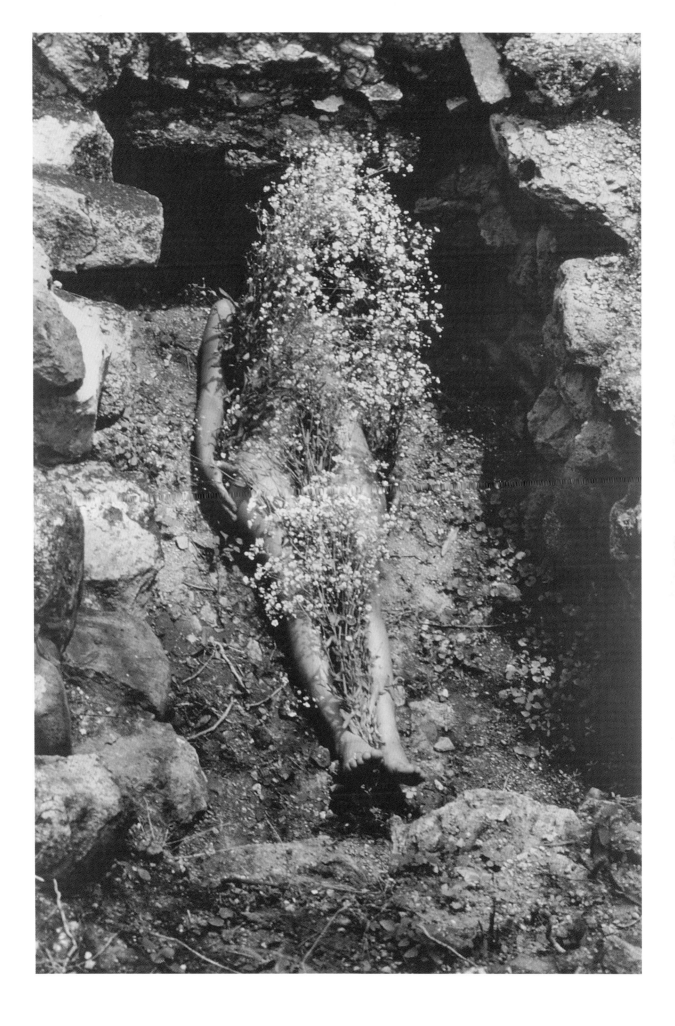

MARLENE DUMAS

(born 1953)

After graduating from the Michaelis School of Fine Art in Cape Town, her birthplace, Marlene Dumas studied art history, painting and psychology in the Netherlands, where she settled in 1976. In 1982, her work was selected to be shown at documenta 7 in Kassel, one of the most important events in the international art world. Two years later, she had her first solo exhibition in a museum (*Ons Land Licht Lager Dan De Zee*, Centraal Museum, Utrecht).

In the 1980s, she abandoned collage, until then her prime means of expression, for oil on canvas and ink wash on paper and also began writing (e.g., *Sweet Nothings: Notes and Texts*, 1998). Since then she has depicted her contemporaries, their bodies and faces, in her distinctive figurative and neo-expressionist style. She often paints portraits from historic documents or mass-produced imagery borrowed from the press and film. She sometimes works from Polaroids of friends and relatives, imbuing these images with a new dimension in her painting: "Painting is about the trace of the human touch", she wrote. "It is about the skin of a surface. A painting is not a postcard. The content of a painting cannot be separated from the feel of its

surface" ("Women and Painting", *Parkett*, Inquiry: Cherchez la femme peintre!, vol. 37, 1993, p. 140).

The universal themes running through Dumas's work are the representation of women and sexuality, violence, death, love, intimacy, childhood, etc. Since the 1990s, she has regularly exhibited in Europe and the United States where her work has received widespread public, critical and institutional acclaim.

The Teacher (sub a) (1987), painted from a photograph, shows a class of uniformed white schoolchildren with their teacher, all with the same vacant, dismal expression on their faces. Beneath the surface this is a critique of the apartheid then in force in South Africa and more broadly of the political and social mimesis within human groups.

The Teacher (sub a), 1987, Private Collection

↗ *The Morning Light*, 1997, Private Collection

87

GUERRILLA GIRLS

(collective formed in 1985)

The aim of this feminist artists' collective, formed in 1985, is to denounce misogyny and racism in the art world – whether on the art market or in institutions or among collectors, the public or artists – with the purpose of reflecting and bringing recognition to women and, more widely, to minorities. The Guerrilla Girls combine popular media (posters, leaflets, advertising inserts, video, actions, stickers and books), factual and statistical data, an outlook of sarcasm and wit and an aesthetic inherited from graphic design (e.g., the legibility of the modernist typeface Futura) and the conceptual art of the 1970s (e.g., Jenny Holzer and Barbara Kruger) to expose the subtext of the dominant culture. With their acute sense of irony, they have created a series of posters in which they directly confront the public, as well as artists, gallery owners and museum curators: *Do Women Have To Be Naked To Get Into the Met. Museum?* (1989). This procedure borrowed from advertising implicates the viewer and incites us to adopt a position.

The seven founders of Guerrilla Girls and the fifty-odd members since 1985 have decided to remain anonymous, in their view the best way of defending their cause.

Their pseudonyms, the names of female artists of the past, give these forebears the renewed recognition they deserve (e.g., Käthe Kollwitz, Alice Neel, et al.). The radicality of the term "Guerrilla", implying clandestinity, is deliberately provocatively combined with "Girls", an overused pejorative term to label women. A fortuitous spelling mistake by a meeting's secretary prompted the Guerrilla Girls to adopted *gorilla* masks to hide their faces. Until 2000, they had produced some seventy posters and stickers, published several books and organized numerous events. However, at the turn of the millennium the group split into three distinct factions still active today: Guerrilla Girls, Guerrilla Girls BroadBand and Guerrilla Girls on Tour.

*Do Women Have to Be Naked
to Get Into the Met. Museum?*, 1989

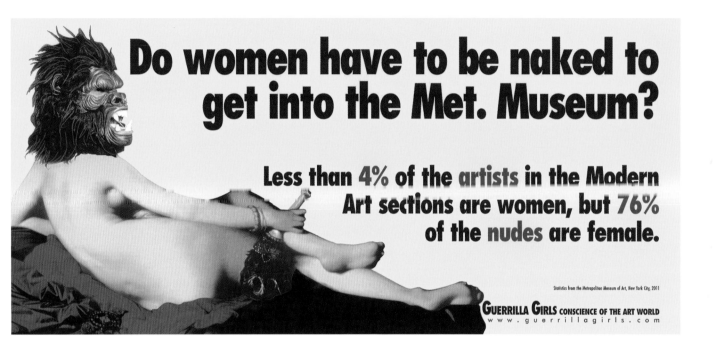

Do women have to be naked to get into the Met. Museum?

Less than 4% of the artists in the Modern Art sections are women, but 76% of the nudes are female.

Statistics from the Metropolitan Museum of Art, New York City, 2011

GUERRILLA GIRLS CONSCIENCE OF THE ART WORLD
www.guerrillagirls.com

KATHARINA GROSSE

(born 1961)

A graduate of the Düsseldorf and Münster academies of fine art, since the 1990s Katharina Grosse has imbued her painting with a monumentality transcending the limits of both canvas and frame. Integrating architecture into its surroundings, she proposes a new use of the pictorial space. Grosse uses vivid, energetically applied colours, abandoning the painter's traditional tools (i.e., oil paint and brushes) for industrial paints and a spray gun enabling her to rapidly cover large surfaces (fabrics, walls, floors, building façades, etc.). The unexpected encounter between a site and paint produces what she calls paradoxes and upsets the conventions of the painted image and encourages change.

Grosse invites the viewer to enter the space of the work to discover multiple viewpoints and perceive painting differently: "What could the painted image be in our society? How could it be visible? How could it be meaningful? [...] How could it be embedded in our other image systems? That's the challenge for me to find a way to make painting visible, make it a visceral part of our everyday life" ("Katharina Grosse: Artist Interview", video, South London Gallery, London, 2017). Since the late 2000s, her work has been shown in numerous museums and galleries in Europe, the United States and Asia (e.g., Palais de Tokyo, Paris, 2005; ARKEN Museum of Modern Art, Ishøj-Copenhagen, 2009; National Gallery Prague, 2019; Helsinki Art Museum, 2021).

In 2016, the director of MoMA PS1, the contemporary art institution of Long Island City affiliated with the Museum of Modern Art in New York, asked Grosse to create a work on a disused miliary base on the coast at Fort Tilden in the New York City borough of Queens. The result was *Rockaway!* Having painted a derelict military building white, she then used vivid artificial red hues, which contrast violently with the natural surroundings, allowing these colours to invade the landscape and engulf the structure itself.

Rockaway!, 2016,
Fort Tilden, New York

TRACEY EMIN

(born 1963)

Tracey Emin studied painting at Maidstone College of Art in Kent and the Royal College of Art in London, where she soon made her private life the main subject of her work. Along with Damien Hirst, Gary Hume, Sarah Lucas and Cornelia Parker, she was one of the so-called "Young British Artists" of the early 1990s, the loose group of visual artists championed by the London gallery owner Charles Saatchi. Their common points were the great freedom in their choice of media, disregard for hierarchies and a certain sense of self-promotion. In her installations, videos, photography, drawings, texts and neon sculptures, Emin's material is raw and autobiographical. Intense, sometimes provocative emotions run through her work – love, hate, desire, violence, obsession – in which she readily evokes her sexuality, her several abortions and miscarriages and, more recently, her experiences with menopause, illness and death.

In *My Major Retrospective*, her first solo exhibition in 1993/1994, she showed an accumulation of works, objects and writings in the White Cube gallery of London. Emin had her first success with *Everyone I Have Ever Slept With 1963–1995* (1995, since destroyed in a fire): in a blue tent she embroidered the names of the 102 people with whom she had slept during her life, not necessarily sexually. Selected for the prestigious Turner Prize in 1999, she created a scandal with *My Bed* (1998, Tate, London), an unmade bed littered with dirty underwear and used condoms. Since the 1990s, her work has been widely shown in Europe and the United States. In 2022, intent on aiding a younger generation of artists, she announced the opening of an art school, TKE Studios, financed by her in Margate on England's southeast coast.

Emin crossed the United States in 1995 from San Francisco to New York. On this journey, she did several readings of *Exploration of the Soul*, her childhood memories from birth until she was raped aged thirteen. In the arid setting of Monument Valley, Arizona, she sits reading this book in a chair inherited from her grandmother and embroidered with the names of her family and important dates, literally making her life an artistic performance.

Monument Valley (Grand Scale), 1995–1997, Tate, London

↑ *My Bed*, 1998, Tate, London

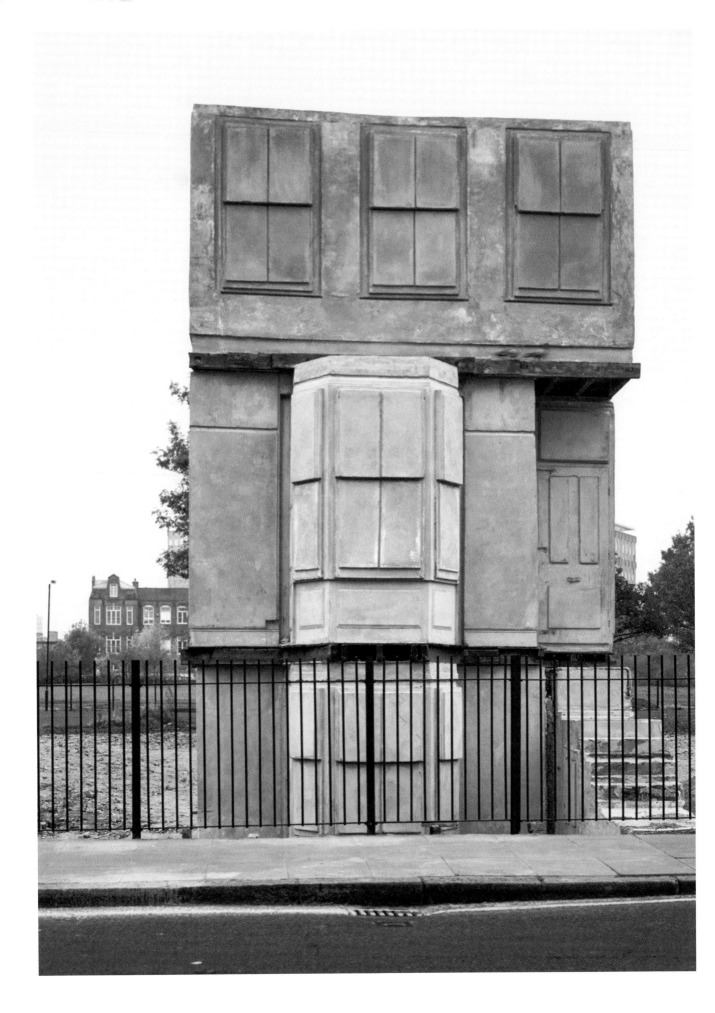

RACHEL WHITEREAD

(born 1963)

Rachel Whiteread's aim is to make the invisible visible, and in her first solo exhibition, a year after she graduated in sculpture from the Slade School of Fine Art, University College, London, in 1987, she showed her interest in giving empty space a concrete form. She soon began making casts of everyday objects, furniture and buildings in delicately coloured materials: plaster, resin, rubber, etc. Traditionally, casting is used to reproduce sculpture, particularly in bronze, but Whiteread turns the technique on its head, using it to give absence and emptiness a tangible presence. Guided by her acute sense of material, she plays with their porosity, transparency, mattness or shininess. By casting a hot water bottle (*Torso*, 1988, Tate, London), a medicine cabinet, a kitchen sink, a mattress (*Untitled (Amber Bed)*, 1991, Carré d'art-Musée d'Art contemporain, Nîmes), the space beneath a chair (*Untitled (One Hundred Spaces)*, 1995, Pinault Collection) or a bookshelf, she stimulates our memory of daily life and examines our bodily and emotional relationship to things and the spaces in which we live. With these forms, she instils the viewer with a strange mixture of familiarity and confusion.

In 1993, Whiteread produced *House* (now destroyed), a cast of a Victorian townhouse destined to be demolished in a London borough in the full swing of gentrification. The building became impenetrable and seemed to resist its fate. It can also be seen as a critique of the policies of Margaret Thatcher (British prime minister from 1979 to 1990), which increased the number of homeless. Whiteread then produced a series of photographs entitled *Demolished* (1996, Tate, London) documenting the demolition of tower blocks, again in a battle against oblivion. Since the early 1990, drawing has played an important role in her work and depicts the art of sculpture with distinct media (graph paper, ink, gouache) in the two-dimensional space of the sheet of paper.

Whiteread became the first woman to win the prestigious Turner Prize, in 1993, and the first woman to represent Great Britain on her own at the Venice Biennale, in 1997. She has also received several major public commissions, including the striking *Judenplatz Holocaust Memorial* in Vienna, unveiled in 2000.

House, 1993, London's East End

FRANÇOISE PÉTROVITCH

(born 1964)

Françoise Pétrovitch's training in the applied arts, notably at the École normale supérieure in Cachan, gave her a taste for technical precision. She works mainly on canvas, with oil and on paper, either in ink washes, as prints or artists' books – media in which she made virtuosic use of empty space – but also sculpturally, in bronze or ceramics. For several decades she has depicted the recurrent themes she calls her "motifs-traits": hands; opened, closed or covered eyes; beasts, whether birds, farm animals, wolves or insects, sometimes merging with human beings; the figure of Saint Sebastian and the "étendus" (e.g., stretched out figures). She uses these characteristic motifs to evoke moments of transition such as childhood and adolescence in a limpid style and to pursue her thoughtful engagement with art history.

In the 1990s, although working on her own on the periphery of the Parisian art world, Pétrovitch exhibited several times in *artothèques*, art centres promoting the democratization of artistic creation. Her work attracted the attention of the art critic and curator Michel Nuridsany, who invited her to take part in a 1995 group exhibition at Le Monde de l'art in Paris.

From 2000 to 2002, she worked on *Radio-Pétrovitch*, a project that involved completing two drawings daily, one inspired by an item heard on the morning news programme broadcasted by radio station France Inter, and the other by a personal or family event. During the same period, she explored the possibilities of mural drawing and ceramics; for example, her installation *Jetés hors d'eux-mêmes* ("Thrown outside themselves"; 2007) is composed of two hundred anatomical horse fragments in black glazed stoneware suspended from the ceiling.

Since the 2010s, Pétrovitch's work has been frequently exhibited and acclaimed by critics (e.g., Musée de la Chasse et de la Nature, Paris, 2011; FRAC PACA, Marseille, 2016; Fonds Hélène & Édouard Leclerc pour la culture, Landerneau, 2021).

DOMINIQUE GONZALEZ-FOERSTER

(born 1965)

A major artist on the international scene, the work of Dominique Gonzalez-Foerster, has been at the crossroads of installation, performance, cinema, architecture and literature since the late 1980s. Devoured by doubt when she graduated from the École supérieure d'art in Grenoble, she envisaged becoming an exhibition curator instead of an artist, but she transformed this uncertainty into a thematic leitmotiv. Each of her works seems to be, above all, a reflection on art and its exhibition: "Exhibition viewers", she said to the curator Emma Lavigne in 2015, "are within the work, not only in front of it. Simultaneously they are passers-by, readers, silhouettes, hesitant as to their movements, creating an assemblage and a specific place with the works in the exhibition. Like the last replicant in *Blade Runner*, they accumulate perceptions and recollections, and adjust them to their own memories. They are also part of what the other viewers see" (publicity material, *Domique Gonzalez-Foerster: 1887–2058*, 2015/2016, centrepompidou.fr).

Recurring motifs gradually took form, all linked to questions of space and memory: the park, the city, the room and also the apparition. Gonzalez-Foerster created environments that stimulate the viewer's subjectivity and incite introspection (e.g., *Cabinet de pulsions*, 1992, Collection FRAC Poitou-Charentes). In her films, she has been particularly interested in places and urban spaces. In the 2000s, she created performances influenced by the films of Orson Welles and Martin Scorsese and designed the concerts of Alain Bashung and Christophe. In 2008, she was the first French artist to use the vast Turbine Hall at Tate Modern in London, where she installed *TH.2058*, an immersive work of science fiction imagining an ecological crisis in which Londoners are threatened by torrential rains prompting the growth of disturbing monumental sculptures in the museum space. In 2012, she began a series of performances and hologram projections evoking the spiritist tradition involving historic figures such as Ludwig II of Bavaria, Marilyn Monroe and Maria Callas (*Opera (QM.15)*, 2016).

Opera (QM.15), still, 2016,
Bourse de Commerce –
Pinault Collection, Paris

NAIRY BAGHRAMIAN

(born 1971)

Nairy Baghramian was born in Iran and emigrated with her family to Germany in the 1980s. She studied the visual arts, architecture, film and the performing arts (theatre, dance, etc.) in Berlin and London. This multidisciplinary training infused her first sculptures, notably in their relationship to space. She explores the body's link to architecture, urbanism and objects by using both an organic and industrial array of surfaces, joints and surgical pins: "To get out of any static mechanism and frozen poses and rethink our position seems to be an important part of thinking further about our societies in general. […] Witnessing how quickly our constructed stability can implode, I couldn't avoid talking about this because the whole idea of collapsing joints comes to the point of our daily life right now" ("Nairy Baghramian: Hugo Boss Prize 2020 Nominee", Guggenheim Museum, YouTube).

Baghramian pursues her explorations of art history and form while examining exhibition practices and the intertwined relationships they create between the viewer, the artwork and the museum. Her sculptures are often erected in unexpected places, such as on the benches provided for visitors to rest, peering into or out of a display case (*Slip of the Tongue*, 2014, Art Institute of Chicago) or along a wall like a handrail (*Von der Stange (Handlauf)/Off the Rack (Handrail)*, 2014, edition for the Museum Ludwig, Cologne).

In *Knee and Elbow* (2020), Baghramian represents two of the principal joints of the human body, the knee and the elbow, necessary for a host of gestures. Along with steel, she utilizes marble, traditionally synonymous with durability and longevity and used in monumental art since antiquity. But she works the surface of the stone not by polishing it to perfection as is the age-old custom but by stippling it to suggest vulnerability. She accompanies this reflection on the history of the material with a meditation on the pose, its conventions and ephemeral nature in the history of sculpture.

Knee and Elbow, 2020,
Clark Art Institute, Williamstown

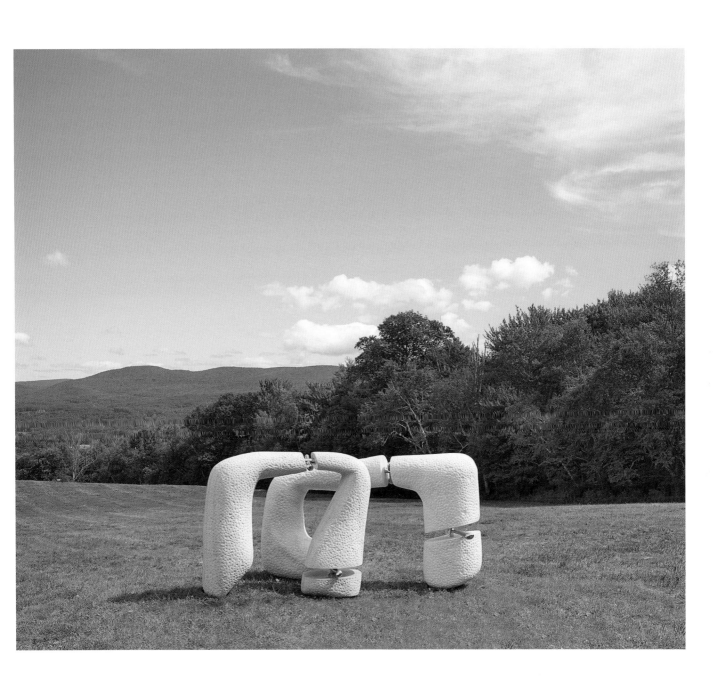

SUZANNE HUSKY

(born 1975)

After graduating from the École supérieure des beaux-arts in Bordeaux and studying landscape design, for the last twenty years Suzanne Husky has pursued a militant and critical ecofeminist position that has produced a multidisciplinary oeuvre – spanning ceramics, tapestry, watercolour, performance, video art, podcasts, etc. – whose main theme is the link between human beings and the animal and plant world. She often uses traditional craft media and folk imagery with dark humour, reinterpretation and dissonance to highlight the aberrations and violence of the capitalist exploitation of nature and the boom of industrial agriculture.

In *La Noble Pastorale*, inspired by the medieval *The Lady and the Unicorn* tapestries, a man, surrounded by delightful beasts and a graceful greyhound in an ornamental landscape, attempts to halt a giant tree harvester from tragically decimating the forest. Similarly, in the tradition of the decorative plates celebrating the events of the 1789 revolution, Husky created vases painted with riot police cordons and environmental activists (*ACAB* series, 2015) and real/fake bottles of household products whose flowery promises are cruelly contradicted on the other side by toxicity warnings (*Douceur de fleurs* series, 2018). The *ZAC de France* series of ceramics (2018) reproduces the façades of the leading retail chains that have invaded the outskirts of towns and cities over the last thirty years. Their reduced scale, the material used (clay) and their decorative motifs endow them with a prettiness far removed from the standardized concrete reality in which they ordinarily prosper. The *DAM BEaVERLY HILLS* installation (2022) celebrates the beaver and its vital role in retaining water, preserving the Californian landscape and preventing the immense wildfires caused by human activity.

In 2016, Suzanne Husky and Stéphanie Sagot founded the New Ministry of Agriculture, the aim of whose actions, publications, performances and collaborative projects is to undermine political doublespeak and the cynicism of institutions.

KAPWANI KIWANGA

(born 1978)

After graduating in anthropology and comparative religion from McGill University in Montreal, Kapwani Kiwanga tried her hand at documentary filmmaking before studying at the École nationale supérieure des beaux-arts in Paris. An integral part of her artistic practice – installations, performance, video – is the preliminary research indispensable for the realization of a work. She is particularly interested in the structural asymmetry of power and its social consequences throughout history; within this context, colonization and slavery hold an important place.

Since 2013, Kiwanga has been working on a vast project, *Flowers for Africa*, begun during a residency in Senegal, for which she was awarded the 2020 Marcel Duchamp Prize. Consulting archive photographs and films of the diplomatic ceremonies marking the independence of former African colonies in the 1950s and 1960s, she noted the omnipresence of complex floral and plant arrangements. At each meeting, negotiation, official arrival and public speech there were sumptuous bouquets and floral arches. She explained, "To keep with the reality of the past – which we can revisit but which has vanished – the idea was to avoid […] any kind of monument to a past moment as though we were trying to cling to it. It was more about recognizing that moment and letting it fade into history – that's what gave me the idea of cut flowers, to allow them to follow their course, to dry up and wilt, which is important" ("Kapwani Kiwanga: 'J'essaie de créer des œuvres qui invitent à la réflexion'", *Magazine du Centre Pompidou*, 13 November 2020, centrepompidou.fr). The reconstructions Kiwanga creates for *Flowers for Africa* take different forms: floral installations and also little triumphal arches of foliage, like the replica in eucalyptus of the arch erected for the festivities around Rwanda's declaration of independence in 1961. The act of wilting evoked by Kiwanga conveys the fleetingness of certain moments in the collective memory but also the many political disappointments after decolonization.

ANNE IMHOF

(born 1978)

Anne Imhof, who was a master student at the Städelschule, Frankfurt's academy of fine arts, from 2008 to 2012, defines herself as a painter, musician and performance artist. Her work is protean, powerful and often immersive, at the intersection of performance, video, photography and sculpture. Her performances in the mid-2010s won her international acclaim. Each of them begins with drawing, the medium she has practiced passionately since adolescence. These images enable her then to imagine the performance structure, to which numerous participants make their personal contribution. The participation of the audience, who often record the event with their mobiles and even broadcast it live on social media, also plays an important role.

Imhof is interested in the contemporary malaise. Inspired by art history and also musical countercultures, she reflects on neoliberal power and the communal through intense shared emotions such as fear, guilt, desire and solitude. In 2017, she was awarded the prestigious Golden Lion at the Venice Biennale for her performance *Faust*, the fruit of a close collaboration with performers, dancers, musicians and photographers, whose intense, crepuscular staging aroused mixed sentiments in its audience regarding the themes of control, transparency, youth and its cult. In her later performances (e.g., *Sex*, 2019), the language of the body continues to play a central role and is at the heart of the images she produces. In *Natures mortes* (Palais de Tokyo, Paris, 2021), she showed an exhibition of her works and also those of some thirty artists she admires, ranging from Théodore Géricault and Eugène Delacroix to David Hammons and Sigmar Polke, and she staged a particularly complex performance lasting four hours.

In *Untitled (Wave)* (2021), filmed on the coast of Normandy, Imhof's artistic collaborator Eliza Douglas whips the waves in a long improvisation as the sun gradually sets, the tide comes in and the sea becomes rough: a human being trying in vain to tame nature, to dominate reality.

Untitled (Wave), 2021

↗ *Portrait of Anne Imhof* by
Nadine Fraczkowski, 2010

107

AD MINOLITI

(born 1980)

After training with the painter Diana Aisenberg and graduating from the Escuela Nacional de Bellas Artes Prilidiano Pueyrredón in Buenos Aires, Ad Minoliti became interested in abstraction, its history and dissemination in mass culture. In an openly critical manner, they stress the extent to which the avant-garde movements throughout the twentieth century were dominated by men who often relegated women to the status of muse or follower and rejected those fields held as feminine, such as emotion, handicrafts and decoration. Minoliti opposes this observation with a humorous, utopian feminist approach full of whimsically playful or else animal images. They use geometric forms eluding binary systems (male/female, cultural/natural, orderly/chaotic, pure/impure, etc.) in order to free these shapes from normative power and a stereotypical conception of gender and sexuality. Minoliti shortened their given name Adriana to Ad to make it more gender neutral. They also use collage to associate abstract forms with photographs from interior design magazines (*Queer Deco* series) or printed pornography (*Play_G* series), a means of hijacking these images from their original heteronormative purpose.

In their exhibitions, Minoliti creates domestic environments with plush seats, bookshelves, tables, etc. in which viewers can make themselves at home, and integrates their own image into mural paintings, thus breaking out of the frame. In doing so, they decompartmentalize the work of art and the idea of the artist's authority. They also deconstruct the "neutral" white exhibition space, supposedly universal but in fact imagined by men for men. At the Centre de création contemporaine Olivier Debré (CCC OD) in Tours, they transformed the gallery spaces into a theatre in 2021/2022 and created a coloured décor for adults and children, alike, in which Minoliti organized lessons by The Feminist School of Painting, which they established in 2018: feminist and queer painting and art history lessons for all, eluding clichés and in favour of sexual equality.

play theater, exhibition view, 2021/2022, CCC OD, Tours

FARAH ATASSI

(born 1981)

A graduate of the École nationale supérieure des beaux-arts in Paris, Farah Atassi works with forms borrowed from the avant-garde movements of the twentieth century as well as the decorative and folk arts. In her painting, she uses these simple geometric shapes (circles, triangles, rectangles) and motifs (stripes, stars, seashells, dots, fruits) as a kind of vocabulary legible for the widest possible audience. "I do figurative paintings with an abstract painter's language", she explained ("A Conversation between Farah Atassi and Éric Troncy", *Almine Rech Newsletter*, no. 25, January–May 2020, p. 65).

For a long time, Atassi depicted interiors devoid of human presence (e.g., *Abandoned Dormitory*, 2011; *Playroom*, 2012). From the late 2010s, she introduced stylized figures into these spaces. She borrowed elements from Pablo Picasso and Fernand Léger, such as their volumeless guitars, "cubist" bodies and faces, tubular figures and striped garments, painting them in flat areas of colour. Shapes in the foreground and motifs in the background intermingle and converse, often using the grid system dear to Piet Mondrian. Her choice of colour palette also plays an important role. Without forsaking black and white, Atassi uses acidulous colours in hues of red, blue, green and yellow reminiscent of the chromatic purity of the Bauhaus and modern artists such as Mondrian and Léger. In their balance and imbalance, the pictures find their own rhythm in the host of forms present on the canvas, some of which, like the recurrent motif of the clock, offer the viewer a focal point.

In *Model in Studio 6*, Atassi explores the theme of the female model in the artist's studio, a subject popular among painters in the late nineteenth and early twentieth century. In the highly composed space, a half-nude woman poses in an armchair. Her deconstructed, geometricized face and body recall the art of Picasso, although he never painted in this manner. The effect of perspective induced by the lines in the background push the volumeless figure into the foreground, while the clock, worthy of Charles & Ray Eames, both destabilizes and attracts our attention.

CLAIRE TABOURET

(born 1981)

For fifteen years, Claire Tabouret, a graduate of the École nationale supérieure des beaux-arts in Paris, has been constructing a figurative oeuvre, somewhere between daily life and the world of imagination. She is interested in the traditional painting genres – portraiture, landscape and still life – well aware of their long history. She readily cites Édouard Manet, Edgar Degas, Paul Cézanne, Pablo Picasso, Giorgio Morandi and Ferdinand Hodler but also works from photographs found online.

Her pictures emanate a sense of melancholy: figures portrayed with gentle, impassive faces stand out against monochrome backgrounds, couples making love, wrestlers, pedestrians seen from behind, masked or outrageously made-up figures, migrants, all seemingly painted with great ease. This diversity prompts a reflection on identity, its disguise and its links with a group or culture. Tabouret has also painted numerous self-portraits in which she scrutinizes her face and body language with a certain acuity: "There is often a visible transformation of the figures in my work, whether it's through costume, makeup, artificial colors, etc., but I also want the viewer to be confronted by the feeling of change. I'm interested in the point when one thing is turning into another – I want to suspend that moment in time" ("In Venice, Claire Tabouret's Figures Transform through Multiple Selves", interview with Angelica Villa, ARTnews, 22 April 2022, artnews.com).

During the COVID-19 lockdown of 2020, Tabouret returned to landscape, a genre she had abandoned for several years (e.g., *Paysages d'intérieurs* [*Interior Landscapes*]). Confined to her studio, unable to work *en plein air*, she invented landscapes from reproductions found in art books. They are painted on synthetic fur, an unusual technique that gives them a cottony, dreamlike atmosphere. In 2021, she produced her first sculptures, cast in bronze and painted, a pictorial evocation of the sudden intrusion of the "real" in *Little Dancer Aged Fourteen* (1878–1881, National Gallery of Art, Washington, DC) by Edgar Degas, wearing a tutu of cotton and silk.

Le Dernier Jour, 2016,
Private Collection

↖ *Self-Portrait (Seated)*, 2021,
Private Collection

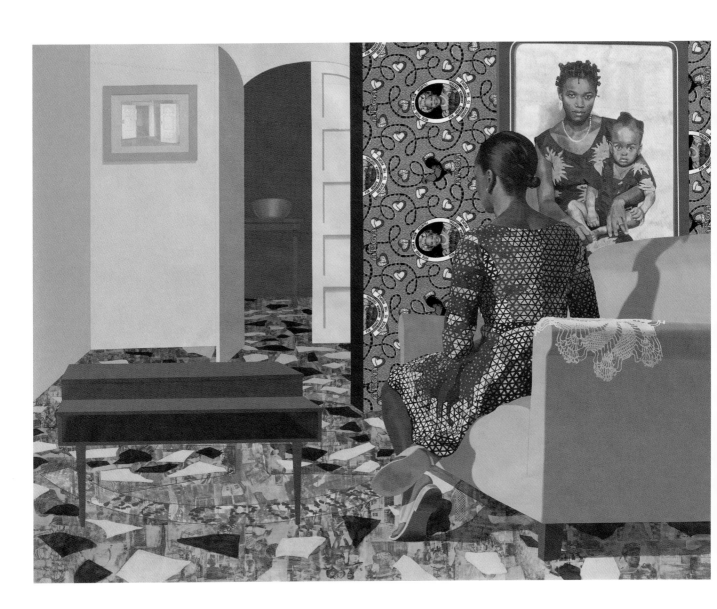

NJIDEKA AKUNYILI CROSBY

(born 1983)

Born in Nigeria, Njideka Akunyili Crosby emigrated to the United States aged sixteen and studied at the Yale School of Art in New Haven, Connecticut. Her work reflects her dual Nigerian and North American cultural heritage. In her figurative compositions, she depicts complex interior scenes with dreamy, seated figures often inspired by works of the past, such as the paintings of Édouard Vuillard. At first sight, she seems to be depicting mundane moments of her daily life at home, which in many respects resembles ours: people talking around a table, a woman stroking the hair of a man reclining on her lap (*Nwantinti*, 2012, Studio Museum in Harlem, New York), another or, perhaps, the same woman sitting in her living room (*Portals*, 2016, Whitney Museum of American Art, New York; *Super Blue Omo*, 2016, Norton Museum of Art, West Palm Beach). But when we look closer, we discover a second layer of meaning. Entire areas of the picture are composed of collaged images taken from the Nigerian press, advertisements and photographs of the artist's family. These collages form kaleidoscopic patterns covering the floor, walls, furniture and garments.

Akunyili Crosby, regards them as representations of strata of individual and collective memory: "I use my work to explore the spaces where disparate cultures overlap, really mining my story or my history as someone who grew up in a very small town, moved to a big city in Nigeria, and then eventually moved to the United States. And really thinking of people who inhabit spaces like that, so thinking of post-colonial spaces and immigrant spaces, spaces where multiple cultures come together" ("Painter Njideka Akunyili Crosby: 2017 MacArthur Fellow", MacArthur Foundation, macfound.org).

In *Mother and Child* (2016), Akunyili Crosby, then pregnant, was reflecting on family relationships beyond death and across oceans. She portrays herself at home, seated with her back to us. On the wall hangs a photograph of her grandmother holding one of her daughters. The floor is covered with a prismatic pattern of images from family albums and popular culture. The wallpaper itself resembles an African wax print fabric and includes a portrait of Dora Akunyili, the artist's then recently deceased mother, a crusader in the struggle against contraband pharmaceuticals in Nigeria.

Mother and Child, 2016, Metropolitan Museum of Art, New York

See also p. 15: *Wedding Souvenirs*, detail, 2016, Private Collection

MEGAN ROONEY

(born 1985)

Megan Rooney, a multidisciplinary artist – working in painting, sculpture, performance, installation, etc. – trained at the University of Toronto and Goldsmiths' College in London. She conceives her work as a series of narratives based on her own experiences and those of her friends and family, also reflecting on the political aspects of intimacy. Her work is often inspired by the ebb and flow of the city and the continual changes in urban landscape. In keeping with this concept, although her pictures are often 200 × 150 cm in format – the edges of which may only be reached with outstretched arms – their narrative is not always legible at first glance.

Her gesture, her choice of colours, often inspired by those of her childhood home, and the materiality of paint on canvas, attest to the exchange between her body and the media – but it also reflects an act of searching. Rooney paints, scratches, erases and repaints as if she were defining a world: "I work in rapid concentrated bursts, moving across the canvas and establishing pathways with my body. […] I don't arrive at abstraction via a direct route. My process is long, idiosyncratic and often erratic. What appears on the surface is not predetermined" (cited in Laurie Barron, "Megan Rooney's Blushing Paintings Return to London", Ocula, 1 September 2021, ocula.com). Some series are figurative (e.g., *Old Baggy Root*, 2018/2019), others are abstract, but all, Rooney insists, are narrative. Her work is traversed by personal myths and stories.

Her mural paintings, which she began to produce several years ago, are also an act of liberation. Intended for museums and institutions (e.g., Palais de Tokyo, Paris, 2018; Salzburger Kunstverein, Salzburg, 2020; Museum of Contemporary Art, Toronto, 2020), they are, by definition, ephemeral and exempt from the logic of the art market, which usually transforms works of art into commercial products. They also refer to the fragility of our existence. Her sculptures, composed of found objects and sometimes painted fabric offcuts (e.g., *Kaputt! Kaputt!*, 2019) and the dancers in her choreographed performances (e.g., *Sun Down Moon Up*, 2018) seem equally vulnerable.

Keeping Quiet, 2020, Galerie Thaddaeus Ropac, London · Paris · Salzburg · Seoul

KUBRA KHADEMI

(born 1989)

Kubra Khademi studied fine art in Kabul University in Afghanistan and Beaconhouse National University in Lahore, Pakistan. In 2012/2013, she created her first feminist performances while working as a set designer in film. The main themes of these early performances is violence, especially violence against women. In one of them, she slaps herself for minutes on end until her cheeks swell (*Slapping*, 2013). In February 2015, for *Armor*, she wore metal armour made from an old gas cooker (a symbol of women's enforced domesticity) that exaggerated the forms of her stomach, breasts and buttocks. She went out into the streets of Kabul and was quickly insulted and intimidated by men crowding around her. Receiving death threats, she took refuge in France, obtained a workspace at the Atelier des artistes en exil (Agency of Artists in Exile), founded in Paris by Judith Depaule and Ariel Cypel. There she continued to draw and create performances, reflecting notably on Afghanistan's image in the world dominated by men and the Taliban and in which women are almost absent.

Several of her series of gouaches, reminiscent of Persian miniatures, show free, nude female bodies without an intention of provocation (*Paraqcha Ha*, 2018; *Series 2019*, 2019; *Ordinary Women*, 2020). Women ride dragons, give birth, apply makeup, display their buttocks or their genitalia, have sex with donkeys or other women – in short, living, breathing women. These works also recount a relationship to eroticism full of humour specific to the female culture of Afghanistan.

In 2021, in collaboration with the American performer Daniel Puttrow, Kubra Khademi worked on a large-scale project, *Let Us Believe in the Beginning of the Hot Season* (video, photographs, gouaches and tapestry) recounting in deliberately kitsch fashion the relationship of domination and submission between Afghanistan and the United States through the loves of a Taliban leader and an American man.

Picture Credits

© George Lange: Collection of Philippa Howden-Chapman and Ralph Chapman, Wellington, Aotearoa New Zealand: pp. 6 (detail), 65

© Bridgeman Images: p. 9

© The Metropolitan Museum of Art, New York. Gift of Julia A. Berwind, 1953, 53.225.5: p. 11

© Photo: Mark Pokorny: p.13

© Photo: Robert Glowacki; Courtesy of the artist, Victoria Miro and David Zwirner: pp. 15, 114

Courtesy of The Hilma af Klint Foundation; photo: Moderna Museet-Stockholm: p. 16

© Kunstmuseum den Haag / Bridgeman Images: p. 17, back cover

© Tate, London, dist. RMN-Grand Palais / Tate Photography: p. 18

Photo © Tate, London, dist. RMN-Grand Palais / Tate Photography: pp. 18, 30, 34, 46, 58, 73, 92, 93, back cover

© Photo: Bill Philip: p. 19

© 2024 Digital image, The Museum of Modern Art, New York / Scala, Florence: pp. 21, 62

© Collection Museum Boijmans Van Beuningen, Rotterdam / photo: Studio Tromp: pp. 22, 23

Rights reserved: pp. 25, 90

Princeton University Art Museum. Gift of the Estate of Kay Sage Tanguy 1964-162: p. 26

© The Metropolitan Museum of Art, dist. RMN-Grand Palais / image of the MMA: p. 29

© Hans Namuth Ltd.; courtesy National Portrait Gallery, Smithsonian Institution; this acquisition was made possible by a generous contribution from the James Smithson Society: p. 31

© Centre Pompidou, MNAM-CCI, dist. RMN-Grand Palais / Jean-Claude Planchet: p. 33

© Archives of American Art, Smithsonian Institution: p. 36

Image courtesy Kasmin Gallery: p. 37, front endpaper

© Paris Musées, musée d'Art moderne, dist. RMN-Grand Palais / image Ville de Paris: p. 38

Photo: Christian Belpaire. Archivo Fundación Gego: p. 40

© Museum of Fine Arts, Houston / Gift of AT&T / Bridgeman Images: p. 41

© Don Myer / Collection SFMOMA: p. 42

© Fern Logan: p. 44

© Philadelphia Museum of Art, Philadelphia, Pennsylvania / Purchased with the Alice Newton Osborn Fund, 1999 / Bridgeman Images: p. 45, back cover

© Carmen Herrera; courtesy Lisson Gallery; photo: Ken Adlard: p. 47

© Saloua Raouda Choucair Foundation: pp. 48/49, 49, back cover

© National Portrait Gallery, Smithsonian Institution: p. 50

Collection Frac Normandie: p. 52

Photo © Centre Pompidou, MNAM-CCI, dist. RMN-Grand Palais / Georges Meguerditchian: pp. 53, 70, back endpaper

Photo: M+, Hong Kong: p. 54

Courtesy Archivio Bertina Lopes (Maputo/Lisbon/Rome) & Roma Centro Mostre: p. 56

© 1964 Bertina Lopes. Photo: Franko Khoury, National Museum of African Art, Smithsonian Institution: p. 57

© Photo: Paula Pape: p. 61

© Gordon Parks / The LIFE Picture Collection / Shutterstock: p. 63

© Jacqueline Fahey: p. 64

© National Gallery of Art, Washington, Gift of Glenstone Foundation and Patrons' Permanent Fund: p. 66

Photo courtesy Faith Ringgold Studio: p. 67

Collection Museum of Contemporary Art Chicago, Gift Joseph and Jory Shapiro, 1992,65. Photo: Nathan Keay, © MCA Chicago: p. 69

Photo: Elliot Storey, Nicola L. Collection and Archives: p. 71

© Donald Woodman / ARS Images, New York, 2024 / Adagp Images: p. 74

© Courtesy Through the Flower Archives / ARS Images, New York, 2024 / Adagp Images: p. 75, front cover

© Committee. Los Angeles MOCA; photo: Brian Forrest: p. 77

Photo: MMCA, Korea: p. 78

© Martha Rosler. Courtesy of the artist and Mitchell-Innes & Nash, New York: pp. 80, 81, back cover

Photo: Achim Thodel Rebecca Horn Collection: p. 82

Staatsgalerie Stuttgart; photo: Rebecca Horn Collection: p. 82

© The Estate of Ana Mendieta Collection, LLC; courtesy Galerie Lelong & Co.: p. 85

Courtesy Zeno X Gallery, Antwerp; photo: Peter Cox: p. 86

Courtesy Zeno X Gallery, Antwerp: p. 87, back cover

© Guerrilla Girls; courtesy guerrillagirls.com: p. 89

Rachel Whiteread, *House*, 1993, concrete; photo: © Sue Omerod: p. 94

Exhibition view, Dominique Gonzalez-Foerster, QM.15, Esther Schipper, Berlin, 2016; courtesy Dominique Gonzalez-Foerster and Galerie Esther Schipper; photo: © Andrea Rossetti: p. 98

Courtesy of the artist, The Clark Art Institute and Marian Goodman Gallery; Photo © Thomas Clark: p.101

© Françoise Pétrovitch, *Étendu*, 2020; courtesy Semiose, Paris; Private Collection: p. 97

Courtesy of the artist, Suzanne Husky, and Galerie Alain Gutharc: p. 102

© Léonard Pongo, 2021: p. 105 Anne Imhof, *Untitled (Wave)*, 2021, video, colour, sound; 30m 19s, featuring Eliza Douglas; directed by Jean-René Étienne and Lola Raban-Oliva; music by Eliza Douglas; courtesy of the artist, Galerie Buchholz and Sprüth Magers: p. 106

© Nadine Fraczkowski / courtesy Galerie Buchholz. p. 107

© Photo: Aurélien Mole; courtesy of the artist and Crèvecoeur, Paris: p. 109

Courtesy of the artist and Almine Rech; photo: Matt Bohli: p. 110

Courtesy of the artist and Almine Rech; photo: Marten Elder: p. 112

Courtesy of the artist; Photo: bluntbangs.bizs: p. 113

Photo: Eva Herzog: p. 117 Courtesy Kubra Khademi and Galerie Eric Mouchet: p. 118

Copyrights

All texts © 2024 the authors
All works © 2024 the artists or their estates

© Adagp, Paris, 2024 for Anni Albers, Farah Atassi, Vanessa Bell, Elizabeth Catlett, Judy Chicago, Gego, Katharina Grosse, Kapwani Kiwanga, Lee Krasner, Khademi Kubra, Ana Mendieta, Annette Messager, Vera Molnàr, Aurélie Nemours, Louise Nevelson, Françoise Pétrovitch, Germaine Richier, Nancy Spero, Charley Toorop, Valie Export.

© Nairy Baghramian

© Benedetta Cappa Marinetti, used by permission of Vittoria Marinetti and Luce Marinetti's heirs.

© Saloua Raouda Choucair Foundation

© Njideka Akunyili Crosby

© Marlene Dumas

© Tracey Emin. All rights reserved / Adagp, Paris, 2024

© Jacqueline Fahey

© 2024 Helen Frankenthaler Foundation, Inc. / Adagp, Paris

© The Estate of Sally Gabori / Adagp, Paris, 2024

© Dominique Gonzalez-Foerster / Adagp, Paris, 2024

© Guerrilla Girls; courtesy guerrillagirls.com

© Carmen Herrera; courtesy Lisson Gallery

Barbara Hepworth © Bowness

© Rebecca Horn / Adagp, Paris, 2024

© Suzanne Husky

© Anne Imhof

© The Hilma af Klint Foundation

© Elaine de Kooning Trust / National Portrait Gallery, Smithsonian Institution

© Estate of the artist Bertina Lopes, courtesy Richard Saltoun, London and Rome

© Estate of Marisol / Adagp, Paris, 2024

© Agnes Martin Foundation, New York / Adagp, Paris, 2024

Courtesy Ad Minoliti and Crèvecoeur, Paris.

© 1991 Hans Namuth Estate, courtesy Center for Creative Photography

© Nicola L. Collection and Archives

© Projeto Lygia Pape

© 2024 Faith Ringgold / Adagp, Paris

© Megan Rooney. Courtesy Galerie Thaddaeus Ropac, London · Paris · Salzburg · Seoul

© Martha Rosler. Courtesy of the artist and Mitchell-Innes & Nash, New York

© Estate of Kay Sage / Adagp, Paris, 2024

Courtesy Claire Tabouret

© Rachel Whiteread, *House*, 1993, concrete

© Wook-kyung Choi Estate

© Catherine Yang

© Zarina; courtesy of the artist and Luhring Augustine, New York

Laure Adler is a journalist, writer and historian specializing in women studies and feminism during the nineteenth and twentieth centuries.

Camille Viéville has a Ph.D. in art history and works as a freelance researcher in Paris. She is the author of numerous texts with a focus on modern and contemporary art and women artists.